DOORWAYS

to HEAVEN

**A SPIRITUAL JOURNEY GUIDED BY ANGELS,
MIRACLES AND THE ART OF ANDY LAKEY**

Keith Richardson

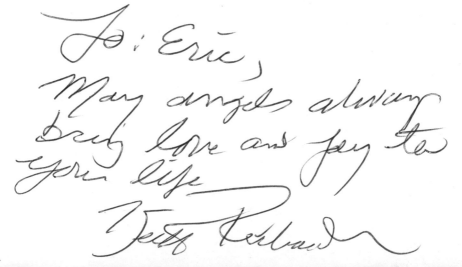

*To Eric,
May angels always bring love and joy to your life*

Keith Richardson

Doorways To Heaven
A Spiritual Journey Guided by Angels, Miracles and the Art of Andy Lakey
All Rights Reserved.
Copyright © 2010 Keith Richardson
V1.0

Outskirts Press, Inc.
http://www.outskirtspress.com

ISBN: 978-1-4327-6080-9

Outskirts Press and the "OP" logo are trademarks belonging to Outskirts Press, Inc.

PRINTED IN THE UNITED STATES OF AMERICA

DOORWAYS

to HEAVEN

**A SPIRITUAL JOURNEY GUIDED BY ANGELS,
MIRACLES AND THE ART OF ANDY LAKEY**

Keith Richardson

With a foreword by:

Raymond A. Moody Jr., M.D., Ph.D.

Outskirts Press, Inc.
Denver, Colorado

CONTENTS

ACKNOWLEDGEMENTS

This book is the product of over a decade of running our spiritual ministry in Ventura, California – Things From Heaven. Our customers have taught us a great deal about God and angels during this time.

I wish to thank my father Ken and late mother Marguerite for having the confidence to financially back our efforts to establish our store even when they thought we were crazy and could not possibly succeed.

I wish to give a world of love and thanks to my wife Francesca for keeping her faith in God and His angels, even when I had given up all hope of success. It was Francesca's faith and vision that allowed everything magical into our store. It is her love that continues to bring happiness to my life.

I am grateful to my son Keith William for his brilliant efforts to design and update my websites for my store and my books. His work has made us known throughout the world.

To my son Kevin I send thanks and love for his many hours of hard work helping me edit and re-write this and my last two

books. He can take some of the credit for the many letters and e-mails of support that continue to pour in about these books.

To Andy Lakey I give my heartfelt thanks. Over the past many years, he and his wife and children have become part of our family. Andy's art and angels, and the miracles they create, have helped me find renewed spirituality in my life.

A NOTE BY ANDY LAKEY

In July of 1995, my administrative assistant gave me a cryptic note from a man named Keith Richardson. She said Keith owned an angel gift store in Ventura, California; a place I had never heard of. He told my assistant that he wanted to sell my art.

At that point in time, with over a hundred galleries throughout the world, I had no intention of taking on a new one. I knew that I already had more work than my small staff and I could handle. I decided that I wouldn't bother to call Keith back.

For some reason, however, I began to feel like I was being guided by spiritual forces and believed that Keith's call was important to me. I had received messages like this before and knew I had to follow God's directions.

I finally called Keith, but I still could not bring myself to be positive about his exhibiting and selling my art in his store. Keith told me of how his wife Francesca had received messages from the angels telling them to open an angel store. They opened their store

on faith alone and with very little financial investment or retail knowledge.

Keith seemed very sincere and his story was quite compelling. I felt drawn to Keith and Francesca's spiritual mission. In the end, I allowed them to be my art dealers. I didn't know it at the time, that this decision would change my life, my art and the lives of thousands of people forever.

Within days of receiving three of my paintings in their store, Keith and Francesca began noticing and documenting miracles happening to people that came in contact with my art. I had heard of things like this happening before, but they had never occurred with such regularity nor were they documented so thoroughly.

I have never proclaimed myself to be a psychic or prophet. I feel that my art is just paint and wood and nothing more. My angel paintings do however appear to increase the viewer's ability to find spirituality in their lives and to discover their higher purpose of bringing God's love to the world.

In this book, Keith Richardson describes how my angel art has changed his life and the lives of many others throughout the world. I wish to thank Keith and Francesca for their continued faith and enthusiasm for me and my art. Their friendship over the past one and a half decades has changed my life too.

– Andy Lakey

FOREWORD

From time to time, since antiquity, artists have appeared whose work has magical qualities. In ancient Greece, Daedalus was a sculptor whose statues were so realistic that people seemed to see them step off their pedestals and walk.

Sometimes, artists receive their calling in the course of a spiritual, visionary experience. Andy Lakey is an artist whose inspiration took the form of a dramatic near-death experience. He says that spiritual beings on the other side commissioned him to complete two thousand angel paintings by the year 2000.

All over the world, there are people who have astonishing visions and spiritual experiences that appear to be brought about by Andy's angel paintings. When I first heard about the phenomenon, I assumed it was collective hysteria. Then, after I wrote an essay for a book about Andy, he was kind enough to send my wife and me a beautiful painting. My wife, a well-grounded businesswoman, swears it started scintillating when she took it out of the box!

Since then, dozens of my family members, friends and students have seen our Andy Lakey painting open up and display amazing three-dimensional, full color visions of every possible theme.

I know it's unbelievable. Nevertheless, I feel no hesitation owning up to an extraordinary phenomenon many of the most solid and grounded people I know have witnessed repeatedly.

I have no idea what the explanation of Andy Lakey's phenomenon will turn out to be, or if an explanation ever will be found. Could it be that the squiggly lines on the paintings alter ones visual perception, I wonder? I confess I have no idea. All I know is that, just as this book reports, many people have extraordinary spiritual awakenings, which were personally significant to them, in the presence of Andy Lakey's art.

I suspect we will be hearing a lot more about this highly unusual phenomenon, which certainly deserves further investigation and reflection. I commend Keith Richardson for putting all these fascinating stories into print.

– Raymond A. Moody Jr., M.D., Ph.D.

PREFACE

The Psychomanteum Effect

Since 1995, I have been experiencing and documenting a phenomenon I now call the "psychomanteum effect." I did not mean to study this phenomenon. I did not want to write books about it. In fact, I had never even heard of such a thing. I just could not deny, however, that something amazing was going on in the gallery in the back of my Ventura, California store. And this phenomenon could not be explained by any conventional scientific methods.

When the phenomenon first began to take place, I tried to find rational reasons for what was happening. I thought the people who had these experiences were mentally ill or possibly suffering from the symptoms of dire grief. When I experienced the phenomenon myself, I even wondered about my own sanity. Then, I started documenting the responses of hundreds of people who entered our store at random each day. Over 80% experienced some sort of psychomanteum effect phenomenon. I could not believe

that this many people could be mentally ill or imagining the exact same thing.

The psychomanteum effect is a phenomenon that takes in many elements. It can range from feeling heat and tingling, to coolness or a magnetic feeling. These elements often occur when one runs their hands over a painting by artist Andy Lakey. It often evokes feelings of overwhelming emotions for those entering a gallery of Andy Lakey's art. It can even include spontaneous healings or receiving messages from deceased loved ones.

After much study of the psychomanteum effect, I have come to the conclusion that this phenomenon is very common and not anything new to humankind. In fact, for much of human history it was accepted as a truth. This phenomenon is related in the earliest writings from Mesopotamia, Egypt, Greece and in Biblical accounts from the Old and New Testaments. It appears to be part of the basis for nearly every religion on earth today. This is a phenomenon of spirituality. It is a phenomenon of understanding the meaning of God and angels. It appears to help people find love and understanding in their hearts for their fellow human beings.

It was not until the European Renaissance of the 15th century, with our overwhelming embracement of hard science, that we began to dismiss the phenomenon of the psychomanteum effect as "nonsense." Our new scientific concepts of the universe have lead many people to become dispirited. They often feel that this is

it. Take all you can get right now. Do not worry how you do it. There will be no consequences for your actions. God and His angels are just myths.

The stories in this book show that there is still much more to life than meets the eye. They give us hope that God and His angels do exist. They provide us with evidence that we do have immortal souls. They also open us up to the possibility that there is much more spirituality in the universe than all of our modern science can ever prove.

CHAPTER ONE

Our Story

Being a logical thinker, I never intended to write a book like this. I was always taught to put my faith in the physical world and to believe there was a scientific explanation for everything. In my mind, people who believed in and promoted their God and angels were just confused or caught up in some kind of wishful thinking.

My university degrees were in anthropology and psychology. I conducted anthropological field research in Nicaragua, Central America from 1976 to 1977. My topic was the psychological relationship between religious rituals and culture. I spent most of my time studying Virgin Mary cults, finding myself amazed by how people could be taken in by such shallow religious practices.

In 1976, I published an article in the scholarly journal, "California Folklore." This article described the cultural relationships to equator crossing rituals practiced in the United States Navy. I had participated in two of these rituals, which

involved acts that can be equated to a fraternity "hazing," while serving on an ammunition ship named the USS Kilauea from 1966 to 1971. Prior to this, I gave presentations during meetings of the American Anthropological Association and the California Folklore Society. For the next eighteen years, I used my logic and scientific research abilities to do marketing, fundraising and public relations for several prominent hospital systems throughout the United States. During this time, I also earned certificates in marketing and fundraising from the University of Southern California and San Jose State University.

My task was to upgrade the images of my client organizations. I was good at this, and I managed to raise millions of dollars for new programs and the construction of medical centers throughout the United States. Although the outcomes of some of my fundraising campaigns were nothing short of miracles, I felt I deserved the credit for this success. I would have thought of it as absurd to credit God or His angels. Nothing in all of my research, university studies or career prepared me for what has happened in my life in recent years.

Our Spiritual background

My parents did not go to church, and I grew up without much religious training. Although I attended Baptist Sunday school as a child, and had belonged to a Methodist youth group as

a teenager, I never attended any church regularly and was not baptized.

My wife Francesca, on the other hand, grew up in a small town in Nicaragua, Central America. She was baptized as a baby, attended Church regularly and went to a Roman Catholic girls' school run by the Sisters of Mercy. Francesca's parents reinforced her beliefs and were part of her community's Roman Catholic faithful. She grew up firmly believing in God, angels and miracles.

As a young woman, Francesca was a devout Catholic. She excelled so much in her faith that the nuns at her school recommended her for entry into a convent to become a novice nun. Francesca's hopes of living an abstinent spiritual life were soon shattered however. She was the oldest daughter in her family, which meant that her parents wanted for her to get married and have their grandchildren instead of pursuing religious training.

In 1972, Francesca's parents made another move to control her life. They sent her to the United States to further her academic education, as well as to remove her from a boyfriend of which they disapproved.

When I met Francesca, she was staying with her brother, Rennie Quesada, who was a friend of mine. At first our relationship consisted only of smiles and shy glances, because we did not speak each other's languages. By 1974, Francesca's

English and my Spanish had improved enough that things started to change.

Francesca and I started dating, and by 1975 we decided to get married. To meet her religious needs, and to please her parents, we decided to be married in the Roman Catholic faith. We found, however, that this was not possible. I was divorced. I had been in a short, unhappy marriage with a woman I had met while I was in the navy several years before.

To the Roman Catholic Church, this was an unforgivable mistake. Francesca and I met with four different priests in various Catholic Churches. All of them told us the same thing. Francesca should find another man to marry. I was unworthy of the church's marital blessing and they considered our relationship to be sinful.

We were eventually married by a Methodist minister in a beautiful church in Pasadena, California. Francesca was so hurt by the cold, uncaring attitude of the Roman Catholic priests we met, that she gave up her Catholic faith altogether. For the next fourteen years, we lived as if there were no God or angels in the universe. Neither we nor our children attended church, and we did not speak of religion in our home.

Our Lessons in Kansas

In 1989, I was recruited by an executive search firm for a job as the director of fundraising and marketing with a national

Kansas-based hospital system run by the Episcopal Church. The position I was offered had been filled by an Episcopal priest for the past forty years. I was concerned about the religious nature of the job, since I felt I was not religious at all. Furthermore, I had a good job with a mental health organization in San Jose, California and did not think I needed to move at that time.

I turned the job down three times, and then made what I felt was an unreasonable request for salary, moving expenses and benefits. To my surprise, all of my demands were met. I knew this was a great opportunity and felt obliged to accept their offer.

When I took the job, it seemed like power, abundance and prestige came to me and my family. We sold our small townhouse in San Jose, California and were able to purchase a beautiful four-acre country estate in Kansas with money left over. Francesca and I joined the Episcopal Church. Our two sons and I were baptized, and Francesca was received into the Church. Over a short amount of time, I was elected a member of the Church vestry and Francesca was elected president of the Episcopal Church Women.

We felt this was our calling. We expected to spend the rest of our lives in our perfect little Kansas town, living in our idyllic country estate. We were wrong. This was only a lesson for us, and a very painful one at that. After just two years in my ideal position, things began to go terribly wrong. The priest who recruited and hired me was fired by the board of directors. A new priest was then

hired to oversee the organization. This man was one of the least spiritual people I had ever met. He demonstrated how one could find a great deal of religion and have no spirituality at all.

Although this priest pretended to be a most kind, gentle and spiritual person, I found him to be deceitful, manipulative and abusive. His management style consisted of threats, humiliation and lies.

Even though my work at the hospital system had helped triple the organization's funds from private sources and doubled full-fee admissions, the new priest believed I was the wrong person for the job. He felt that my position should be held by an Episcopal priest, not a lay person. He made my life miserable with his threats and abuse over the next two years. When I did not quit, he fired me.

How We Found Grace

I launched a nationwide job search, sent out hundreds of resumes and interviewed for dozens of jobs, but I could not find work. We returned to California, discouraged and financially strapped. My parents suggested that we move near them in the coastal city of Oxnard, located about an hour north of Los Angeles.

Things then seemed to be looking up. I was offered a job which appeared to be the opportunity of a lifetime. A Latino man from Los Angeles, with powerful political ties to Mexico, offered

me a full partnership in his international trade organization. I took this position and arranged many lucrative trade agreements between the United States and Mexican business interests. In the end, I was cheated out of my commissions and slandered by my partner. I lost everything I thought was important, my career, my good name and my financial stability.

At that point my family was really in dire straits. We had lost so much we were on the verge of being homeless. Furthermore, we could not pay our bills and our credit was destroyed. I was pushed to the point where we suffered the humiliation of having to apply for public assistance and received welfare and food stamps. In order to keep from being evicted, we rented two rooms of our home to strangers. I continued to look for employment of any kind, but found nothing.

Seeing the gravity of our situation, my parents tried to help us. Two of my father's friends were on the board of a local charity that needed someone to run a thrift shop for them. My father told them I had twenty years experience in nonprofit organizations and had managed several thrift shops during that time for these groups. My father's friends asked for a proposal from me, and I quickly produced one for them. Once I submitted the proposal I was told the project was in committee for study. They said they would get back to me, but they never did.

With my father's backing of a $5,000 loan, I then set out to establish a thrift shop of my own. I first wanted to find the best place to open my shop. I did research on the community and found that the best local place to operate a nonprofit thrift shop was on Main Street in Old Town Ventura. This was very convenient, since it was only about ten miles from my home in Oxnard.

This is where Francesca and I began looking for a vacant storefront in the summer of 1994. We walked the streets of downtown Ventura for several months and became more and more discouraged. There did not seem to be any places available for us. Even when sites were vacant, property owners did not want to rent to us because we had no previous retail experience. It looked as though there was no hope for us.

Francesca's Message from Heaven

In the midst of our darkest hours, Francesca began having recurring dreams. She would find herself walking outside and looking skyward to see clouds. Then the clouds would open up to reveal hundreds of beautiful angels. The angels would smile at her, and she would smile back at them. She was confused by this ongoing vision and felt that it must be some sort of message from God.

These dreams continued until January of 1995, when Francesca had a completely different vision. Alejandro, a

childhood friend from Nicaragua who had died the year before, came to Francesca with a beautifully bound golden book.

"What're you doing here, Alejandro? You're supposed to be dead," Francesca asked in surprise.

"I know I'm dead, but I've been sent here to bring you this book."

"What kind of book is this?" asked Francesca.

"Read the book with me and find out."

Alejandro opened the golden book. To Francesca's amazement, she found that it was filled with a multitude of information about angels. Francesca read passages that stated ideas such as: "angels are beings of light," "angels are messengers of God," and "angels bring God's love to the world." Francesca read the entire book in her dream.

At about five in the morning, she woke me up and began to tell me about this dream. She went on and on about the book and Alejandro, but I finally told her to go back to sleep. I was sure now that the stress of me being out of work and our terrible financial condition was getting to her. She had obviously started to imagine unrealistic things.

Later that morning we were eating breakfast with our two sons, Keith William and Kevin, when Francesca enthusiastically related her dream to them. She kept repeating how amazed she was that she read the entire book during her dream.

Kevin, our youngest, who was thirteen at the time, shook his head and said, "No mom. I don't think so mom."

"What is this Kevin?" Francesca snipped defensively. "First your father doesn't want to hear about my dream, and now you don't want to hear about it."

"It isn't that I don't want to hear about it," Kevin responded calmly. "It's that you can't do what you said you did. You can't read in a dream. One side of your brain reads and the other side of your brain dreams, you can't do both things at the same time. Either you didn't read the book... Or it wasn't a dream."

Francesca and I stared at each other for a moment. We believed Kevin could be right, but this left us without an explanation of what had occurred.

"I know I read the book," Francesca said. "I still remember what I read."

With that, she again began quoting the verses in the book she had read several hours before, "Angels are messengers of God, they're beings of light, and they bring God's love to the world. I really know what I read."

Later that day we again walked down Main Street in Old Town Ventura, searching for a site for our proposed thrift shop. To our surprise we found a storefront with a "for lease" sign in the window. We spoke to the owner of a hardware shop just down the way from the location. He told us that the landlord's office for that

property was just around the corner, in an old Victorian house. We walked over to the office and stepped inside. There we met the owner's representative, a man named Bruce. He seemed excited to find someone interested in leasing the property.

The storefront was in the worst part of Old Town Ventura. There was an abandoned liquor store and a twenty-four hour adult book store on one side, and a junky antique shop operated by a part-time merchant on the other. Upstairs was a transient hotel, which we learned housed members of a prison release program.

The awning of the storefront hung down in shreds. There was a street person living in the recessed entrance to what would become our shop. He asked us for a quarter as we walked by him.

The inside was even worse. The building had most recently been used as a drug rehabilitation recreation center. Rotting couches lined both sides of the room for about fifty feet. The carpet was hidden under a two-inch layer of cigarette butts. The place had recently been fumigated, leaving dead rats and cockroaches spread across the floor among the cigarettes.

As we walked further into the building, things continued to get worse. The back room was filled, from floor to ceiling, with trash. This included broken furniture, rotting carpets and old mildewed mattresses. At the very back of the building was an old washing machine and dryer. Next to these sat a large pile of dirty

clothes. The restroom walls were slathered with black moss. The restroom light fixture was full of water from a leak in the ceiling.

Francesca looked at this hopeless mess, this renovation disaster, and announced, "This is perfect. This is where we're supposed to be. We're not supposed to have a thrift shop. We're supposed to have an angel store. That's what my dreams have been about."

I disagreed and explained to her, "We don't know anything about running a retail gift store. We don't know where to buy angel gifts. We don't know how to display angel gifts. And, we don't know how much to sell angel gifts for."

"We can learn," Francesca replied optimistically. "I got a message from God to open this store. We need to do what God wants us to do."

There was no arguing with her. When Francesca makes up her mind about something, there is nothing anyone can do to change it.

I called my father, a man with many years experience in property management, to help me negotiate the lease with the landlord and sign it for us, since we had no credit. We got what we felt was a fair lease deal. This included two months of free rent to give us time to refurbish the building, and a one year trial-lease at about half of what similar properties in the neighborhood were leasing for.

After the lease had been settled, my father and I went to our new building. We sat down on the step that separated the two sections of the store. My father then turned to me and said, "Keith, how are you going to make this place into a thrift shop? What charities are you going to contact?"

"We've changed our minds," I explained. "Instead of a thrift shop, we're going to open an angel store."

"A what?" my father replied.

"An angel store!" I answered more firmly.

"What the hell's an angel store?" he asked.

"It's a store that sells angel gift items," I timidly answered.

"Like knickknacks?" he asked.

"Yes dad, like knickknacks."

"Well, let me get something straight," he continued, "you want to have a knickknack store that sells only one type of knickknack."

"Yeah, that's right," I replied.

"Well that's about the dumbest idea I've ever heard of in my entire life," he explained, genuinely frustrated. "You guys are going to be bankrupt and living on the streets in a few months and I'm going to be stuck with the lease payments. I'm not going to go through with this idea, and I'm not going to lend you a penny if you don't give up this stupid idea of starting an angel store."

"But dad," I pleaded, "Francesca has made up her mind. If it isn't an angel store, she doesn't want anything to do with it."

"Keith, then why don't we compromise?" he suggested. "I'll loan you the $5,000 on the condition that you make this a food store and not an angel store. Sell a few angel gift items, if that appeases Francesca, but don't make angels your store's major products or I'm sure your business will fail."

Things From Heaven – An Angel Store

We opened our store on April 1, 1995. There was little fanfare and very few people came to share our grand opening with us. The original name was "Things From Heaven - Food and Gifts." We had no sign, no telephone and did no advertising. These luxuries required money we did not have.

We found right away that our customers were not interested in the food. It just gathered dust on our shelves. They were only interested in the angels. Within three months of opening, we had to close out all of our food and sell only angel gift items. We also changed the name of our store to "Things From Heaven - An Angel Store."

During the first several months after opening, miraculous things began to happen. Our store was chosen to be blessed by the monsignor from the San Buenaventura Mission, located down the block from us, and an ugly old cabinet we used as a display

bloomed into a spontaneous shrine. The most important miracle to happen, however, was the arrival of Andy Lakey's art into our store. Even with my stubborn skepticism, I could not stop it from coming to us. When something is God's will, nothing can prevent it. Andy Lakey's art, angels and miracles have greatly influenced our store's success and changed the lives of my family and myself forever.

CHAPTER TWO
Messages from Heaven

In order to understand this book, one must be familiar with artist Andy Lakey and his story. Andy is the world's most famous living angel artist. His art is in the Vatican and collected by American presidents, movie personalities and European royalty. Andy's story and how he became an artist is, however, quite humble and very spiritual.

Andy Lakey was not trained to be an artist. He did not even want to be an artist. He sold cars and used his money to buy drugs. He prided himself on the quality of the cocaine he took. He did not care about anyone or anything.

On December 31, 1986, Andy went to a New Year's Eve party. There he "free- based" cocaine with his friends. As the evening went on, he began to feel worse and worse. Andy felt as if his head was going to explode and his whole body was shutting down.

Andy did not tell his friends how bad he felt. He thought he was too "cool" to overdose. He instead told his friends he would

"see them tomorrow" and left the party for his downstairs apartment. By the time he got to his apartment, Andy was crawling on his hands and knees. He entered his apartment, crawled into the shower, turned the cold water on himself and started to pray for the first time since he was eight years old.

"God, if you spare my life, I'll never take drugs again and I'll do something to help the world," Andy pleaded. At that second, he felt something swirling around his feet like a tornado. He looked down, and to his amazement saw seven glowing beings of light swirling around his body. The beings shined like the sun and looked like they were made of crystal. They came up to his chest and put their arms around him. Andy felt at peace. He knew that the angels had saved him.

Andy had a near death experience that night, surrounded by his seven angels. He saw the light of God and glimpsed the other side. After recovering, he stopped taking drugs cold turkey, began helping other people and became obsessed with drawing what he saw in his near death experience.

Andy quit his job, moved out of his apartment and left all of his friends behind. He found a new job and a new place to live. Each night when he came home instead of taking drugs, he drew what he saw in his near death experience on yellow lined paper. This continued for three years. By this time, Andy had boxes of sketches of what he had seen on the other side.

In October of 1989, a feeling that he was not doing what he was supposed to do obsessed Andy. He was so moved by this feeling that he quit an $85,000 per year sales job, took all his savings out of his bank accounts, bought $6,000 worth of art supplies and built an art studio in his garage. He felt compelled to paint the images he saw in his near death experience.

When Andy finally completed his art studio and sat down to paint, he discovered something was terribly wrong. He had no art training and did not have the slightest idea how to make the paint he bought stick to his canvases. He would start to paint at the top of the canvas and the paint would drip down to the bottom. He tried and tried, but everything he painted looked like mud.

Several months passed, and Andy became more and more discouraged. He sold a painting for one hundred dollars, but the person returned the next day and asked for her money back.

One morning, as he entered his studio, a strange and amazing thing happened. He had rigged the door of his studio so that when it was opened the lights would come on and his radio would play full blast. The radio began blaring out the song "I Can't Get No Satisfaction" by the Rolling Stones as Andy opened the door. Across the room Andy saw something very unusual, a small ball of light came through the wall and touched him on the forehead. He felt a tingling sensation run through his entire body.

As this happened, Andy felt as if he was transported into another dimension. Three apparitions of bearded men appeared to him.

These men explained, "The reason you were spared is that you have a mission to fulfill."

Andy asked them what his mission was.

They responded, "Your mission is to paint 2,000 individual angel paintings by the year 2000."

Andy interrupted, "But I can't do that. You know I can't paint."

The men reassured him, "Don't worry about a thing. Put it all in our hands and we'll take care of everything for you."

This entire meeting felt as though it took several hours, but when the men disappeared, the radio was still playing "I Can't Get No Satisfaction."

Andy left his studio in a daze. He wandered around town and ended up in a furniture store. He felt he was supposed to buy a couch. He really did not need one, but he could not shake the urge. Above the couch that he felt compelled to buy was a wonderful painting. It was by the artist Roger Hinojosa from Sedona, Arizona.

Andy got Roger's phone number from the furniture store and called him at his Sedona studio.

"I've just become an artist and I need your help. Your art is so beautiful and mine looks like mud. What am I doing wrong?" asked Andy.

"What kind of paint are you using Andy?" Roger replied.

Andy told Roger the brand of paint he was using and Roger said, "Andy you're using the wrong paint. No wonder everything you paint looks like mud."

Roger told Andy the correct paint to purchase, and Andy went to the art supply store where he had purchased his paint originally. He traded some of the unused paint he had purchased earlier for the paint Roger suggested.

Andy took his new paint home and prepared to paint a masterpiece. He laid out his canvases, opened his paints and got out his brushes. Then, to Andy's great concern, he accidentally knocked over the painting table. This spilled his old and new paints all over himself, all over his canvases and all over the floor. Andy left his studio, overwhelmingly frustrated by the situation.

The next morning, when Andy entered his studio to clean up the mess, he found something wonderful had happened. When the first paints he had purchased mixed with the new paints Roger suggested, they puffed up. The dried mixture did not push in and did not chip off easily. Andy used this mixture to form the basis for his textured art style. He worked day and night on several

paintings. When he was done, he felt another urge, this time to go out for dinner.

At this point, Andy had very little money left, but he felt compelled to go to one of San Diego's finest restaurants. When he got there, he recognized a friend of his. They had dinner together. Andy told the friend he had become an artist. The friend told Andy she worked in a bank, and that she could see if the manager would allow him to display his art there.

The manager agreed to let Andy place his art in the bank. Within hours of having it there, a major art collector entered the bank and saw Andy's art. He called for his art collection specialist, Pierrette B. Van Cleve, to see this most unusual art. Pierrette visited Andy at his studio. On seeing and touching the art, she realized that it would be very beneficial for blind people due to its interesting textured surfaces. At Pierrette's suggestion, the art collector commissioned Andy to paint a special series of paintings for his home in Canada. Andy did the paintings and used the money he was paid, along with Pierrette's endorsement, to paint his first major art display and present his first major art exhibit.

In just a few months, Andy had a full gallery opening at the Swan Gallery in San Diego, California. Six hundred people attended. This event was a success, and his exhibit sold out. One person attending the event was a Monsignor on vacation from Italy. When the Monsignor returned to Italy, he spread the word

about Andy's angel paintings. Within weeks, Andy got a call from the Vatican. Pope John Paul II wanted a painting. Andy sent the Pope painting number one in the series of 2,000 angel paintings he was told to paint by the men that appeared to him in his studio.

Today, Andy's art hangs in museums and art galleries around the world. His most famous collectors have included King Juan Carlos of Spain, Prince Albert of Monaco, Princess Margaret of Great Britain and King Hussein of Jordan, as well as Presidents Ford, Carter and Reagan. Celebrity collectors have included Ray Charles, Stevie Wonder, Quincy Jones, Shari Belafonte, James Redfield, Ed Asner, Patty Duke, Ron Howard, Lindsey Wagner, Gloria Estefan, Dennis Hopper, Kelsey Grammar, Naomi Judd, General Chuck Yeager, Arnold Palmer and John Travolta.

Despite his fame, Andy has stayed true to his mission. He donates a significant amount of his art to help others. He supports children's charities throughout the world. The Blind Children's Center in Los Angeles is on the top of his list of children's causes.

Andy also supports charities for abused women, AIDS research and animal welfare. Andy's art continues to help people throughout the United States and around the world to find faith, hope and spirituality, and to face life's challenges with greater peace and understanding.

CHAPTER THREE

How Angels Brought Us
Andy Lakey's Art

It was May 1995 and our store had only been open for thirty days, when a very striking woman named Pam came into our store. Pam appeared to be in her late thirties. She had jet black hair and piercing gray-blue eyes. From the beginning, Pam was impressed with our endeavor.

"I love this store," she told us. "I love everything about this store. I love the energy here. You should be selling international art in this store."

I try to be a realist about things, however. I knew our store was pretty humble. We had started it with only $5,000 and the place was a disaster. Our shelves were bare. There was a curtain that hung precariously in the center of the store to block all of our unused space. There was nothing sold in our store for more than $30.

Furthermore, Old Town Ventura was also a disaster. During the first three months that our store had been open, the city had initiated a major downtown renovation project. They cut down all the trees along the road, tore out the sidewalks and closed off

the streets. With the exception of the homeless people who lived in the park across the street, few people came into our store at all. I told Pam we were not quite ready for international art yet.

"You should be selling artist Andy Lakey's paintings in your store," she continued undaunted.

"Who's Andy Lakey?" I asked.

"He's the most famous living angel artist. His art is in the Vatican. He's been on lots of television shows. He's been on 'Sightings,' 'Life Styles' and the NBC special 'Angels: The Mysterious Messengers.'"

"I think I saw him on 'Sightings,'" I replied, and then continued confidently, "but I don't think our store is ready for his art yet."

"I disagree with you. I know you're really wrong. Your store is ready for Andy Lakey's art. You've got to promise me something... Promise me that you'll call Andy Lakey."

Pam left the store, and I let it go. I never made a call or even tried to find a phone number for Andy Lakey. This all just did not seem realistic to me.

Two months later, Pam returned to our store. She marched right up to me and asked demandingly, "Have you called Andy yet?"

"Andy who?" I replied, slightly confused.

"Andy Lakey, the artist I told you about the last time I was in your store. You've got to call him and you've got to call him right now!"

"I appreciate your interest, but let's be realistic," I tried to rationally explain to her. "There are hundreds of beautiful gift stores throughout California, and there are hundreds of art galleries throughout the state of California, where an artist like Andy Lakey can sell his art. Why would an internationally famous artist like Andy Lakey want to sell his art here?"

"Look, I love everything about this store," Pam continued as though she had not heard me. "And Andy Lakey's a friend of mine. I used to work with him ten years ago. I saw Andy last week at a gift shop in San Juan Capistrano and I told him about you guys. He said he might be interested in having his art in your store. You've got to call him and you've got to call him right now!"

"Do you know his number?" I asked.

"No," she demurred.

"Do you know what city his studio is in?"

"No."

"I'll contact him later then," I told her, not really planning to keep that promise.

Pam looked at me a little sad and confused and said, "I'm not leaving this store until you call Andy Lakey!"

Now I was concerned that I might be in the presence of some kind of mental case. I considered calling 911 to get the police to take this lady away. At that very moment, however, I noticed a copy of *Angel Times Magazine* that we had for sale on our counter. The cover advertised an article about Andy Lakey.

I grabbed it, opened it, and there on the inside back cover was the toll-free phone number (800) LAKEYART. I knew that I had nothing to lose, the call was even free. I called the number and got an art gallery in upstate New York. I asked to speak to Andy Lakey.

"Andy Lakey isn't here," the voice on the line said. "He doesn't live in New York, he lives in California."

I was given another phone number to call. I called this number and got a person who said she was Andy Lakey's assistant.

"I would like to sell Andy Lakey's art in my store," I said boldly.

"I can't be very encouraging about this," she replied smugly. "We have over one hundred galleries selling Andy Lakey's art across the United States and we have no intention of opening any new galleries in the near future."

"Well there's a lady here who says her name is Pam, and she used to work with Mr. Lakey. She says she recently saw him and told him about my store, and he told her that he might be interested in having me sell his art."

The woman then became more stern and said, "Let me tell you something about Andy Lakey. He's a nice guy. He tells a lot of people a lot of things. But, I assure you of one thing, he has no intention of opening any new galleries in the near future."

"Well, thanks anyway," I said feeling discouraged.

As I started to hang up, the woman shouted, "Wait! If you'd like, I'll take your name and number, and someday, if we ever decide to open a new gallery, maybe we'll give you some consideration."

I felt that I was wasting my time, and I was about to tell her to forget it. At that point, though, I looked up at Pam. She was looking right through me with her cold gray-blue eyes. I thought to myself about how if I didn't leave my name and number with this woman on the phone, Pam would continue coming to my store to bother me forever. I left my phone number with the woman and, to my surprise, two days later I received a call from Andy Lakey.

"I've heard of your store, I might be interested in business with your store," he told me. "But, I've got some major, major concerns."

My head filled with images of my store and thoughts about its bad location and the terrible shape it was in. But, feeling that I didn't have anything to lose by that point, I boldly asked, "What are your concerns Andy?"

He paused for a moment and then explained, "Well, my major concern is I don't know where Ventura is. Where are you from San Mateo and San Juan Capistrano?"

I would later learn that Andy had galleries in both of these California cities.

"We're really far from both of those places," I answered defensively.

We talked for about an hour about everything, and when we were done we had a deal. I had to purchase three paintings right away. I did not have the money to buy these paintings, so I took a leap of faith and sent him our rent money. The three paintings we received were really small. The largest was eight by ten inches, the next largest was six by eight inches and the smallest was five by seven inches. We moved our curtains back five feet and put the paintings on the wall under a light fixture. This was our first Andy Lakey art gallery. We soon realized that we could not sell these original paintings, because we would then have nothing to sell at all. So, we took orders.

Andy Lakey and I did not meet until March of 1996, nearly one year later. My wife and I went to his studio, which was about a three hours drive to the south of our store. When we arrived, we sat and talked with him about our store and his art.

Finally, as the conversation lulled, Andy Lakey looked at me and asked, "Could you please refresh my memory a little, and tell me how you came to get my art in your store?"

I told him the story about his friend Pam. I explained how her persistence led me to buy his art for my store. He shook his head and said, "No! That's not what happened. That's not how I remember it at all."

"What do you think really happened?" I asked.

"What really happened," Andy answered, "was that the angels brought you to me. The angels bring me everything, and they brought you to me too."

I smiled and said, "Maybe you can tell something like this to your television interviewers or to reporters from tabloid newspapers, but you can't tell me this because I was there. I know what really happened."

"What do you really think happened?" said Andy, now smiling.

"What really happened was that your good friend Pam, whose opinion it appears you respect, told you about our store and you decided to give us a try based upon her recommendation."

"There's something I should tell you about Pam," Andy said seriously. "She's not a good friend of mine. I worked with her ten years ago. I saw her at a gift store in San Juan Capistrano last year and I hadn't seen her before and I haven't seen her since.

Hundreds of people tell me about stores I should display my art at every time I do an art show. I seldom, if ever, act on their advice. But, when I learned about your store, it was like I received a message from God. And these messages are never wrong. I have to do what God tells me."

"What do you mean by that?" I asked.

"I know it was divine intervention because when I acted upon this message, your little store in Ventura began to sell more of my art than any other gallery in the world."

To this day "Things From Heaven," in its unlikely location, is Andy Lakey's number one gallery for sales and dollar volume. More people own Andy Lakey's art in Ventura County than any other county in the world. It is now the world's oldest and largest ongoing exhibit of Andy Lakey art.

Wow, there's an Energy!

We had been selling Andy Lakey's paintings in our store for just over a week when a very conservative looking woman, who appeared to be in her late seventies, came into our store. She had blue-gray hair and was dressed in a navy blue pinstriped suit. She carried herself with an air of dignity. My thoughts upon seeing this woman revolved around how she looked like she could afford to buy a painting.

I proudly showed the woman the three small paintings we had on the wall. As I did this, I casually and unconsciously ran my left hand about an inch in the air above one of the works of art as I described how and why Andy Lakey created these paintings. At that moment, I felt something beyond logic and reason. I felt heat and a tingling sensation similar to having pins vibrating all over the palm of my hand. I was shocked that I really felt something. I couldn't believe something like that was happening to me.

I was concerned that if I said something about my experience, the conservative customer might leave my store in a hurry, thinking that I was having a psychotic episode or something. So, I tried to play it cool. I slowly lowered my hand away from the painting. Then I put my hands behind my back and stepped away from the painting.

At this time, the woman walked over to the painting, she looked at it for a moment and finally reached out and put her hand near the spot where I had just had my experience. She immediately flicked her hand away as if she had just come in contact with a hot stove.

"Did you feel that?" she asked, looking a bit surprised.

"Feel what?" I replied cautiously.

"The heat and the tingling that's coming off the painting, is there something behind it?"

I took the painting off the wall and showed her that it was just a painting on wood. "I felt it too, and I'm just as confused by it as you are. Nobody told me that these paintings did this," I said bewildered.

For the next week, I had everyone who came into the store run their hands just above the paintings to see what they experienced. Eight out of ten people that tried it felt some sort of heat or tingling.

I called Andy Lakey's office and spoke to his assistant about this phenomenon. She said that she had heard of things like this happening, and told me that I should call Paul Robert Walker, a man who was doing research for a coffee table book entitled *Andy Lakey: Art, Angels and Miracles*.

I called Paul and introduced myself. I told him I had a gallery of art by Andy Lakey in Ventura, California and was puzzled by a phenomenon that was taking place.

"What are you experiencing?" asked Paul.

"People are experiencing heat and tingling when they put their hands just above the paintings," I explained. "Is this a local phenomenon? Is it caused by power lines under my store? Or, is it possibly due to our store being on a spiritual grid that runs from the city of Ojai, to the east of us, to the Channel Islands, to the west of us?" The idea of this spiritual grid comes from Native

American folklore, which holds that a strange energy field exists between Ojai and the islands off of our coast.

"This isn't an isolated incident," said Paul. "It's not a local phenomenon either. I'm getting reports of this type of experience from people from all over the United States. Last year when Andy Lakey was featured on the television program 'Lifestyles,' the show's host, Shari Belafonte, was so amazed by what happened to her while filming the segment that she wrote a chapter about it for my new book. I'll read it to you," he said. "I remember feeling this sensation up my arm, whoo-oo-oo, like a burst of energy. And I remember thinking that's the difference…That's what's really special about Andy Lakey's art."

I thanked Paul for his help and went away amazed and very grateful that this phenomenon had been further verified. Since these early experiences, tens of thousands of people from throughout the United States and from around the world have experienced the wonder of Andy Lakey's paintings.

The Paintings Know Where They Belong

As soon as we received our first three paintings, strange things began to happen. Within minutes of hanging them on the wall, a customer named Martha entered the store. Martha was thin and pale and she walked with a limp. She told me she had recently been diagnosed with terminal cancer.

35

Martha claimed to possess psychic abilities and said she did card readings at a local coffee house. She prided herself on using the Bible to find answers to people's problems when she did her readings. I thought it all sounded sort of silly.

Martha closed her eyes and put her hands over one of the paintings. "These paintings are very spiritual," she said. "Each one has its own special purpose."

The first painting she moved her hand over was six by eight inches, depicting a pink angel with four rays of light coming down behind it.

"This paining has a child's energy in it," said Martha. "It can help a child find spirituality in his life."

The next was a blue eight by ten inch painting. It had three angels and five rays of light.

"This painting will help in doing group healing," said Martha. "It could be used to help members of a youth group find peace, love and understanding in their lives."

She then ran her hand over the third and final painting of our exhibit. This was a six by eight inch painting with two angels and four rays of light.

"Wow! This is the most spiritual painting of the three," she proclaimed. "This painting can be used to help people go to the other side in peace. It should go to a hospice group of some sort."

Martha's analysis was interesting, but I really did not believe what she had to tell me.

The next day a well known psychic from Santa Barbara came to our store. He had learned that we were selling Andy Lakey's art and wanted to experience it firsthand. I could not resist questioning the man about what he felt the meanings were of each of our three little paintings.

"As a psychic, what spiritual meaning does each of these paintings have?" I asked.

He closed his eyes and ran his hands over each painting. Then to my shock, he began to repeat nearly word for word what Martha had told us about the paintings the day before.

"This painting has a child's energy and should be in a child's room," he said pointing at the six by eight inch painting with the pink angel. "This painting is for a youth group," he said pointing at the eight by ten inch painting with three angels. Finally, he looked at the six by eight inch painting with two angels and four rays of light, and said, "This painting would offer people facing death hope. It should be hung in a hospice."

The odds against these two separate predictions being exactly the same were very small indeed. What later happened with these paintings was even more amazing.

We did not tell anyone about the psychics' predictions, and we did not try to sell the three paintings. We took orders and

commissioned spiritual energy paintings. We used the money we received from the sale of a painting to order more for the store. Once we had accumulated about a dozen paintings we began to sell them from our walls.

The first of the three original paintings we sold was the one that was supposed to have a "child's energy." A young man, whose wife was pregnant with their first child, saw the painting and said he felt there was something about it that he felt would help his child find spirituality in his life. He purchased the painting for his new son's room.

The next painting to go was the one that we had been told would help people find peace in facing death. It was purchased by members of a senior citizen group that met weekly to discuss spiritual topics. The group's leader, who purchased the painting, said that he felt the painting might help group members face their deaths with more peace, dignity and understanding.

The fate of the first two paintings was amazing. Nothing would surprise us now. The final painting was supposed to hold group energy. It needed to help a group of people find spirituality.

The third painting, however, did not go to the right person. A woman suffering from cancer purchased it. She said this painting helped her endure the pain of her disease more than any of her cancer medications. Whenever she ran her hands over this painting, she said she felt peace and comfort. She said its energy

was very powerful. At the time, I felt that this purchase proved that what happened with the other two paintings was just a coincidence.

One month later, the woman who bought the third painting returned to the store. We had just received a new eight by ten inch painting by Andy Lakey. This was one of the most striking paintings he had ever produced. It had the outline of what appeared to be the Virgin Mary surrounded by angels.

When the woman saw it, she became obsessed with it. She said it made her feel even better than the one she had originally purchased. I told her, if she would like, she could trade her original painting for the new one. She was elated and returned the next day with her painting, and took the new painting home with her.

We hung the painting, which the psychics said had "group energy," back on the wall of our gallery. Within two weeks, a representative of a local youth group purchased it. I was amazed. All three paintings had indeed been sold to the exact places the two psychics had predicted. I had to admit now that Andy Lakey's paintings were not purchased at random. They know who they belong to.

CHAPTER FOUR

Psychomanteum Encounters

In the fall of 1995, we built an art gallery in what used to be our store's storage room. At first it was very primitive. We did not know how to place our halogen lights, and they shined in people's eyes. After some analysis, we tore our whole lighting system apart, ripped out the old fluorescent light fixtures on the ceiling and set up a much better lighting system with fifteen halogen lamps.

By the spring of 1996, we had put the finishing touches on our gallery. We extended it another twenty square feet, added a video tape player and installed new carpeting. I also sprayed the ceiling midnight blue and, just for fun, put up glow-in-the-dark stars. It was shortly after this time that very strange things began occurring in our gallery. These included people receiving full-color, 3-D messages from loved ones on the other side.

At first I dismissed these visions as hallucinations, or possibly symptoms of extreme grief or mental illness. After seeing this happen again and again to people of all ages, races, religions

and cultural backgrounds, I have become more convinced daily that something very real and otherworldly is taking place in our store's art gallery.

After completing what I thought was the final draft of my first book, I read Dr. Raymond Moody's book *Reunions*. In this book, Dr. Moody explains his thirty-year study of psychomanteum phenomena.

Psychomanteum roughly translates from Greek as "theater of the mind." Scholars seeing the function of these spiritual centers in ancient Greek myths originally thought they were just fictitious plot elements. They called them "The Oracles of the Dead."

In myths, psychomanteums helped characters such as Odysseus and Hercules to deal with the grief of losing loved ones. These spiritual centers also brought people the messages they needed to solve their problems.

Psychomanteums were proved to really exist when a major site from the Greek myths was discovered and excavated in Greece near the Albanian border in the early 1900s. Upon excavation, this spiritual center was found to be a large underground chamber. It had a number of cubicles for initiates to sleep in. It also included a maze that led to a large room with a brass caldron in it.

Initiates stayed in the psychomanteum for twenty-nine days. On their final day, they entered the maze and followed it to the room with the caldron in it. The caldron was polished like a

mirror. When initiates gazed into the caldron, they saw lost loved ones and received reassuring messages from the other side.

Many scientists still dismiss the concept of psychomanteums as a hoax. They believe that the temple priests hid inside the caldron and pretended to be the initiates lost loved ones. As a cultural anthropologist, I find this theory hard to believe. How could a highly sophisticated, well-educated people like the ancient Greeks be fooled completely by a simple trick like this? Furthermore, how could they be fooled for the more than one thousand years that psychomanteums existed in their culture? It seems evident that some sort of spiritual contact must have occurred in order for this tradition to be passed on for so many generations.

The tradition of the psychomanteum continues in our culture to this day. The elements of many books and motion pictures including: "The Sixth Sense," "Harry Potter," "Signs", "Star Wars," "The Matrix," and "Lord of the Rings," as well as most of the ghost stories prevalent in our culture, contain definite psychomanteum descriptions. These include spiritual images appearing in mirrors, pools of water or crystal balls. They also often contain stories of ghostly messages sent to the living from loved ones on the other side.

Dr. Raymond Moody (best known for coining the term "near death experience") was so impressed by this concept that he

built his own versions of psychomanteums. His "spiritual centers" consist of a darkened room with a mirror. Here, people in grief stare into the mirror until they receive messages from the other side. The psychomanteums Dr. Moody designed experience success rates as high as 88% in bringing people in grief together with their lost loved ones.

We did not intend to establish a spiritual center in our store. In fact, I had never heard of a psychomanteum. We just stumbled upon this phenomenon as it occurred over and over to our customers in Andy Lakey's art gallery. The configuration of the store with a long narrow maze of angel gifts leading to a separate room filled to the top with spiritual art accidentally created a psychomanteum on Main Street in Ventura, California.

It seems ironic that although I did not mean to create a center of this type, that I now give presentations on the "psychomanteum phenomenon" throughout the United States. Dr. Moody even invited Andy Lakey and me to give a "psychomanteum Symposium" at the University of Nevada at Las Vegas. This event, held on a Monday evening, in a very out of the way lecture hall on campus, still managed to fill the room with over three hundred people to hear us speak on this amazing spiritual discovery.

I feel that the art of Andy Lakey helps open people's hearts, souls and minds so they can feel, hear and touch loved ones in the

spiritual world. I was skeptical at first about a phenomenon like this, but after seeing numerous occurrences of this at our store, I have accepted the fact that this phenomenon is indeed real. The following stories show how the "psychomanteum effect" has helped many of our customers come to grips with their grief and find new paths to happier, more spiritual lives.

A New Path for Sundance

In late summer of 1996, a Native American man came into our store. He was a large man with strong facial features. He was dressed in ragged clothing and smelled like he had not bathed in weeks.

He first encountered my son Keith William, who was nineteen at the time and working in our store. The Native American man looked disdainfully at my son and said, "Working in a store like this, you probably believe in God. Don't you?"

"Yes," my son replied cautiously.

"Well I don't. I don't believe in anything anymore. I think it's all crap," the man angrily shouted.

"I think you have to talk to my mother," said Keith William. He then called for his mother, Francesca, who was working at the back of the store at that moment, "Mom, I need you."

Francesca came to our son's aid. As she did, the Native American man shook his head and said sternly, "Are you the owner of this store?"

"Yes I am," she answered.

"Well, my name is Sundance, and I've got something to tell you."

"What is it?" asked Francesca.

"There is no God! If there was, He wouldn't have treated me so badly."

"What do you mean?" Francesca politely asked.

"Well, two years ago I was very happy. I had a good job, a beautiful wife and two wonderful sons. Well all lived on the Apache reservation in Arizona. One day we were driving home and a drunk driver hit us head on. My wife and sons were all killed. Only I survived.

"After this happened I gave up on life. I left the reservation and got involved in drugs and alcohol and crime and violence. I have drifted from town to town. I have lived on the streets of Ventura for the past six months. My life is worthless. There is nothing you, God, or anyone can do for me."

"You have to pray about your situation," said Francesca consolingly.

"Prayer won't help anything, there is no God," Sundance stated hopelessly.

"Then come and see the art in our gallery," said Francesca undaunted.

Sundance reluctantly followed Francesca into the gallery.

"This is really stupid," he said under his breath as he followed Francesca. But, when Sundance entered the gallery, his mouth dropped open. "I recognize these angels. They're the angels of my people," he said in amazement.

Francesca then told him to find a painting that called to him, to put his hand just above it, and to pray about his wife and his children. Sundance found a painting in the corner of the gallery that had one large golden angel on it. He placed his hand over the angel, closed his eyes, gasped, and seemed to go into a trance. After not moving for about five minutes, tears began to pour from his eyes.

"I've been wrong," he cried. "I've been so wrong about everything. I just saw my wife. She said that she loved me and that she was always going to love me, and not to worry about her – that she's happy where she is now. She said I had to go on with my life and find another woman to love and marry. Then I saw one of my sons and he said, 'Daddy I love you. I'm always going to love you and don't worry about me I'm happy where I am now.' Then I saw God, and He told me I was on the wrong path. I had to return to the reservation and work with orphaned Indian Children. I'm going back. I'm going back to the reservation to tell all the apache people

to come to your store and find the spirituality you allowed me to find."

The next day, Sundance returned to the store to bring Francesca a crystal. "This crystal represents the power of the universe," he explained. "Use it to keep the power of God in your store."

He returned again the following day with a Native American herb called sweet grass. "This herb should be burned in your store every day to cleanse any negative energy that might get into it."

The third day, Sundance returned with a member of the Hell's Angels motorcycle club. He brought Francesca a copper bracelet, said a final farewell and left on the back of a Harley. He has never returned to our store.

I was skeptical about this entire incident. To me, though, Sundance was just a sociopath street person who was conning my innocent, trusting wife.

Ashley's Birthday Wish

In August of 1996, a mother, daughter and grandmother came into our store. They were looking for pictures of angels to have engraved on a memorial plaque for Kathy, the grandmother's daughter, the mother's sister and the little girl's aunt. Kathy had

died in May. They found what they wanted depicted on some of our angel stickers.

While pursuing other gift items, the mother came upon the shrine we have in the back of our store. She wrote an intercession that read, "God please hold Kathy in your wings until she grows wings of her own."

As the three ladies came to the counter to pay for their goods, eight-year-old Ashley said she wanted to write an intercession to God as well. She got a piece of paper from our shrine and wrote, "God, Lord. Please don't let Kathy slip through your hands like she slipped through mine."

"Would you please help me put my prayer on the shrine?" Ashley asked her mother.

"Can't you see I'm busy buying these things?" her mother answered curtly.

"Don't worry Ashley. I'll go with you," Francesca said kindly.

I totaled up their order while Francesca and Ashley walked to the back of the store to tape her prayer on the shrine. Ashley became very emotional and began to sob openly.

Francesca guided the young girl into the art gallery and tried to comfort her. She said, "Ashley, find a painting on the wall that you feel your aunt Kathy is in and put your hand on it."

Ashley found a small painting by Andy Lakey with four pink angels on it. She then placed her hand over it.

"Close your eyes and say a prayer to God about your aunt," said Francesca.

Ashley appeared to go into a trance and made a soft gasping sound. After four or five minutes she appeared to recover a bit. She began to cry more profusely. Three long teardrops ran down each eye. She appeared to be dazed and confused.

"I saw aunt Kathy and she said, 'Happy Birthday'," Ashley repeated over and over.

Skeptical as I was about this phenomenon up to this point, I knew now that something was really happening this time. I did not think that an eight-year-old girl could make this up. She was crying too hard for this to be a childish prank. I asked Ashley's mother if I could talk to Ashley about what she saw. Her mother agreed. I brought a tablet of legal paper with me to take notes.

"What did you see Ashley?" I asked.

"The first thing I saw was clouds. Then the clouds opened up and I saw beautiful golden gates. Then the gates opened up and I saw God."

I interrupted at this point and asked, "What does God look like?"

"God was beautiful," she said. "He had long brown hair and a brown beard. And he wore a long white gown that glistened.

50

I said, 'God I want to see Aunt Kathy and I want to see her now!' God then answered, 'Ashley, Ashley what you're asking me to do is against the rules. We don't usually do things like this here, but you're such a nice little girl and I'm such a nice man, so I will break the rules today and let you see your aunt Kathy for just a minute.' The next thing I remember is my Aunt Kathy coming to me on a cloud." Ashley continued, "My aunt said, 'Ashley I love you, I'm always going to love you, don't worry about me I'm happy where I am in heaven.' Then she said, 'Happy Birthday Ashley, I've always loved your birthdays' and she held my hand softly. Then she said, 'Ashley there's something I want you always to remember. Never, never ever give up your dreams.'"

After this, Ashley said that her aunt told her that she had to go back to God. Ashley saw her float away. The golden gates closed and Ashley came back to consciousness.

Tina's Heavenly Vision

Twelve-year-old Tina was a child actress who had appeared in major motion pictures, including starring roles. Tina first came into our store with her mother and one of her mother's friends who was a regular customer at our store.

Francesca showed Tina our art gallery, while her mother and her friend shopped in the front of our store. Tina immediately fell in love with Andy Lakey's art. She was particularly attracted to

a pencil sketch by the artist. She took it to the front counter, where her mother and her friend were waiting, and purchased it.

"Before you go," said Francesca, "I want all of you to go back into the gallery and run your hands over one of Andy Lakey's paintings so you can feel the energy."

Tina returned to the gallery and found a painting on the wall that she felt called to her. She put her left hand just above it, closed her eyes and said a prayer. Tina then appeared to go into a trance.

After about five speechless minutes, Tina's first word was, "Awesome!" Tina told her mother, "You won't believe what I just saw!"

"What did you see?" her mother asked in surprise.

"I saw your friend Linda who died last year. She said she was cremated, and you scattered her ashes over the ocean. She said to thank you for the beautiful plaque you made for her. She says it looks beautiful on the pier."

Tina's mother was flabbergasted. "How would you know about this? I never told you, did I?"

"No, you didn't," Tina answered, shaking her head.

Neither Tina nor her mother could explain what had occurred. Francesca and I knew that Tina had received a message from the other side.

Police Officer Michael Clark

In the fall of 1994, police officer Michael Clark was gunned down while trying to negotiate a domestic crime. He was the first police officer from Simi Valley, California (about a half hour drive from Ventura) to be killed in the line of duty. He left behind a wife and a five-month-old child.

About a year later, Officer Clark's widow, Jennifer, came to our store. Francesca showed her into our art gallery to see Andy Lakey's paintings. Initially, Jennifer was skeptical. She said she did not feel anything coming from the paintings at all.

"Close your eyes and put your hand above a painting that calls to you, and say a prayer to God," Francesca suggested.

Jennifer noticed a pyramid shaped painting with three large angels on it. She put her hand above two of the angels, closed her eyes and prayed. Suddenly, she drew in a quick, deep breath and opened her eyes and stared at the painting. She then seemed entranced for the next few minutes. Afterward, she began to cry hysterically.

Between her tears, she sobbed repeatedly, "That was weird. That was really weird."

"What is it?" Francesca inquired.

Jennifer could not answer for several minutes. She finally said, "I saw my husband, Michael. I always wondered what happened to him after he was shot. I also wondered how he would

feel about my having another man in my life. Michael said, 'Don't worry about me. I'm happy where I am. You need to go on with your life.' He also told me that it was all right for me to find another man to love."

Jennifer left our store shaken and confused. She returned several months later and wrote the following statement:

"I came to Things From Heaven last September and put my hand over a painting by Andy Lakey. I immediately felt peace about my husband's murder. My husband Michael came to me and let me know that everything was going to be okay. I felt that Michael was at peace and really in a better place. It's been two years now since Michael's murder and I know now, since I touched Andy Lakey's painting, that my life is going to turn out fine."

Mark and Scotty are Together Again

Claudia came into our store with tears in her eyes. Her family had dropped her off with us as a last resort. She was totally distraught and could not even speak to tell us what her problem was.

Francesca came to her aid. She gave Claudia a smile and a hug, and then led her to the art gallery in the back of our store to sit down. Francesca stayed with her for a few moments and tried to calm her down.

"What's the matter?" Francesca asked consolingly.

Tears rolled down from Claudia's eyes as she began to pour out her life's tragedies. "My son Mark was killed in a street gang confrontation four months ago and my father died of complications from Parkinson's disease two months ago. I have also had four other close relatives die in the past six months. I don't know what to do. I can't go on living with all this pain."

"We have had many people like you, who have lost loved ones, come to our store. With prayer and the art in this room, some of them have been given the peace needed to go on with their lives," Francesca explained. "Are you familiar with the art of Andy Lakey?"

"No," Claudia replied.

Francesca explained Andy Lakey's story to Claudia and told her to find a painting on the wall that called to her, to put her hand over it and to say a prayer. Claudia did as Francesca instructed.

Claudia found a painting on the wall at the far end of the gallery and put her hand over it. After a few moments, she again began to cry, but now even harder than before.

"Oh my God!" she exclaimed. "I just had a vision. I saw my murdered son Mark and my father Scotty. They were together. Mark was sitting down and Scotty was standing up with his arm around his shoulder. They were smiling at me with the most

peaceful look I've ever seen. They told me not to worry about them, that they were happy where they were and that everything is going to be okay."

Claudia left our store in a daze. She could not get the images of her father and her son out of her mind. Two months later Claudia awoke in the middle of the night with an overwhelming compulsion to put the images she had seen in our store on paper. She stayed up all that night doing pencil drawings. The next day she began to convert her drawing into a painting.

Claudia had no formal training in art, but she found that the colors and the pictures in her mind poured onto the canvas like a rainbow of spirituality. The painting in the end showed Claudia's son and father together. Behind them were swirling plateaus of reds, greens and blues that appeared to be ethereal plains.

One puzzling piece of the painting was that the figures of her father and son had no faces. When asked, Claudia explained that they seemed so peaceful and happy when she saw them in her vision that it was impossible for her to convey this in her painting.

When the painting was completed, Claudia reported that she felt the presence of angels all around her, and throughout the world as well. She believes that the encounter with the painting by Andy Lakey touched her life forever. The healing vision she received continues to give her the strength and hope to carry on with her life.

The Walls are Still Opening Up!

It was late Tuesday afternoon in January, when KCAL Channel 9 from Los Angeles completed filming a special television program on angel encounters in our store. Katherine, the director of a local hospice, claimed she had an angel experience in our store in 1997. She believed she had seen a portal open up in the wall of our gallery. Katherine said this portal led to another dimension – the dimension of the spirit world.

Our employee, Jane, was in the back of our store closing up. She had just turned off the lights when she saw Katherine standing in our gallery of Andy Lakey paintings at the back of our store.

Jane pointed to a painting that Andy Lakey had created based on the hands of my wife Francesca and myself, and said, "This is the spot where I first had an experience with Andy's art. The first time I came to this store, I saw a bright white ray of light come out of a painting that hung there."

Katherine looked at the spot that Jane was pointing to and said, "You know that's really strange. This is the exact spot that I saw the wall open up last year."

As Katherine spoke, our employee experienced a strange sensation. She felt a strong pulsating motion coming from the center of the painting. As she looked at the painting, she saw a bright circle of white light start to form in the center of the

painting. As she continued to watch, the circle of light began to grow larger. In its center was a void of sheer blackness.

Jane gasped in amazement, "My God what's that?" She screamed for me at the top of her lungs, "Keith! Keith!"

Katherine grew concerned and said, "Jane be quiet, you're going to close the vortex. I don't want that to happen again. I want to know what's going on. I want to see the other side. I think they have a message for us."

Jane grudgingly agreed not to speak. Then, both women reported seeing the circle of pulsating light grow even larger. As this happened, white glowing figures surrounded by bright golden light began to leave the vortex and enter the room. Several of the figures flew right through Katherine's body. Katherine accepted them willingly. She felt they were angels.

After a while, the beings of light began to return to the bright circle in the center of the painting. In just seconds, everything in the gallery was just as still and calm as it was before.

Katherine and Jane ran into the front of the store where Francesca and I were closing out the cash register. They appeared physically and emotionally shaken by their experience. We brought them chairs so they could sit down. Each woman reported what had happened to her in our art gallery. Their stories were strikingly similar.

Jane asked, "Keith, didn't you hear me calling for you? I screamed your name as loud as I could several times."

Francesca and I looked at each other confused and then shook our heads.

"We didn't hear a thing," I responded. "The music was off, the fans were off and the store was totally empty and silent. We should have heard something." In slight disbelief, but with a gradual change in my skeptic viewpoint, I added, "Maybe the things you saw weren't in our gallery at all. Maybe both of you were on the other side with the angels when you called us."

My Mother Isn't Dead!

It was a crazy December's day at our store. Our store is always busy the Sunday before Christmas, but this day was especially frantic. Maybe this is why the forces from the other side seemed more active than ever in our gallery of Andy Lakey art.

At about 3:00 p.m., a rather striking woman walked into the store. She appeared to be in her early forties and had dark black hair and deep brown eyes. She said her name was Marilyn.

"I don't know why I came into your store," she said. "I've never been here before. I didn't know this store even existed. I just felt drawn to come in."

"A lot of people tell me this," I assured her. "Did you find a place to park right in front of our store?"

"Yes," she nodded with a surprised look on her face, "how did you know?"

"It happens here all the time," I explained. "We don't know why for sure, but generally when this happens, there is a good reason for you being here."

Marilyn smiled and confirmed, "You're right, I do have a reason for being in an angel store. My mother passed away last week from complications of a long term illness."

"I'm sorry to hear about your mother," I said, "I lost my mother last year, and I know how hard it can be."

Marilyn then looked at me a little cautiously and said, "I haven't told anyone this. They'd think I'm crazy, but I think I can trust you. The night of my mother's death, I dreamt that I accompanied her to heaven."

"What was it like?" I asked.

"It was beautiful. We walked down a path lined with the most beautiful bright colored flowers, grass and trees. They glowed like neon. My mother was holding my hand. It was really beautiful. I remember when I stepped on the path it would change colors under my feet. I was awakened from this dream by the ringing of my telephone. It was the hospital calling to tell me my mother had died."

I looked at Marilyn reassuringly and explained, "What happened to you is not abnormal. The majority of the people who

lose loved ones see them again as spirits. It's just the few dispirited people in the psychiatric and medical professions who are making us think we are crazy when this happens. For millions of years, we as humans have experienced this sort of thing, and it has helped us. It has just been in the past century in which we've been told these experiences aren't normal." I made a gesture to Marilyn with my hand and said, "Come with me into the gallery of art by Andy Lakey. You'll see for yourself that what I'm saying is true."

Marilyn followed me through the door at the back of my store into the gallery.

"Have you heard of this artist?" I asked.

"No," she replied.

I told her Andy's story and described his mission to paint two thousand angel paintings by the year 2000. The story and the art fascinated Marilyn.

"You can touch these paintings," I said. "But if you put your hand about an inch above them, some people feel something coming off them. Try it."

Marilyn cautiously put her hand over the painting. "Wow! There's energy in those paintings!" she declared. She went around the gallery, trying all of the paintings, getting similar results from each.

As she explored the paintings, my employee, Jane, entered the gallery with a family of four: a father, mother and two

daughters. Jane told the family about Andy's art, and she had them run their hands above it. Their younger daughter, Isabelle, a Hispanic girl in her early teens with braided pigtails, put her hands over one of the paintings and closed her eyes.

A few seconds later, Jane called me over to her side, "Oh, my God Keith! I think it's happening again. Look at that girl."

Isabelle was in a catatonic trance-like state. Her eyes were closed, but they fluttered beneath her eyelids.

"I think you're right," I said in awe, "there really seems to be something going on here." After a few moments Isabelle came back to consciousness. I asked her, "Did you see anything?"

"Yes," Isabelle answered calmly, "I saw my mother. She was reaching out to me." Isabelle then put her hand on a second painting, went into the same catatonic state, and when she opened her eyes again, she stated, "I was holding my mother's hand."

Her father, who was standing next to me, informed me, "Isabelle is our foster child. She just came to live with us."

The family stayed in the gallery just a little while longer, and then went to the front of the store. They related Isabelle's experience to my wife, Francesca, and knowing of the psychomanteum phenomenon common in the gallery, she asked the girl, "When did your mother die?"

"My mother isn't dead," Isabelle replied in a confused, yet matter of fact, manner.

The family left the store after making their purchases and Francesca went to the back of the store, where I was still with Marilyn, to tell me of her concern. "No one has ever seen a living loved one come out of the paintings," Francesca said.

I did not have an explanation, and was just as confused by the situation. Jane entered the gallery and we told her of our concern.

"Didn't Isabelle's foster father tell you what happened?" Jane responded in surprise. "They just got Isabelle as a foster child because both of her parents were killed. No one has told her yet of the tragedy. They brought her here today to help her deal with the news when she finally receives it."

I Was Holding My Grandma Judy's Hand

One Sunday afternoon in February, our employee Jane came running to the front of the store to get me. She was frantic with excitement. She motioned to me with her hand and said, "Keith! Keith! Come quick. It's starting to happen."

"What's happening?" I asked impatiently.

"The psychomanteum!" she shouted. "It's becoming active again. You've got to see what's going on."

I walked briskly behind Jane as she led me into the gallery of Andy Lakey's art. There, directly in front of me, was a six-year-

old girl named Dakota with her hand over one of Lakey's paintings. The little girl appeared to be in a trance.

After a short moment, Dakota opened her eyes and looked at her mother, a woman with short blonde hair who appeared to be in her late twenties, and declared, "Mommy, mommy, I feel like I was touched by Jesus. I saw Grandma Judy. I was holding her hand."

Dakota's mother began to weep openly. "Oh my God," she said, "her grandma died last year. They were always very close."

I stepped in at this point and asked the distraught woman a few questions, "Have you ever been to our store before?"

"No," she replied, "I didn't even know your store existed until today. We just stumbled upon it by accident. We're not from around here. We're from Ridgecrest, California." Ridgecrest is a city about two-hours southeast of Ventura.

"Have you ever heard of Andy Lakey?" I asked.

"No, not until just now when Jane showed us his art. What's going on here anyway?" she demanded.

"Well," I said, "this may seem a little hard to believe, but from time to time people who come into this gallery of Andy Lakey's art see departed loved ones and get messages from the other side. We think that is what just happened with your daughter."

The woman looked bewildered. I showed her the book I had written about similar experiences and told her of Dr. Raymond Moody's book *Reunions*, which further describes this phenomenon. I then asked, "Would it be possible for me to talk to Dakota about what she saw, so I can further document what's going on in our gallery?"

The woman thought for a moment, and then nodded yes.

I went to the front of the store and got a yellow legal pad to take notes on. When I returned to the gallery, I walked over to Dakota and asked her, "What did you see?" After I asked this question, the young girl fell silent and ran over to her mother, held onto her leg and refused to speak. I looked at Jane and said, "I don't think she wants to talk to me. She seems to like you. Maybe she will tell us what she saw, if you ask the questions."

Jane walked over to Dakota and began to do something that greatly concerned me. She asked her very unscientific, leading questions.

"Did you see your grandmother in heaven?"

"No!" replied Dakota. "My Grandma Judy was in a park in Chicago. We used to go there a lot together."

"Were there angels with your grandmother?"

"No!" Dakota responded, "Only my grandma was an angel, she had beautiful white wings and wore a long white gown that

shimmered. The only other things I saw with her were her little dogs."

Dakota had named several animals she had seen when her mother, who was standing with us, sobbed and said, "Those were the little dogs she had that died."

Jane then continued her questioning, "Dakota, did your grandmother tell you anything?"

"Yes, she did. My grandma said she loved me and that we'd be together again in heaven one day."

Dakota's mother took me aside and said, "This is all very traumatic, and Dakota doesn't know it, but her grandma Judy committed suicide six months ago. My husband and I are strong Christians and we've been taught to believe that you go to Hell if you kill yourself. It's really reassuring to know that this isn't true. I'm really happy to know that Grandma Judy's in heaven and happy with her little dogs."

Don't Be Afraid Kristen

On a slow Monday afternoon, a ten-year-old girl named Kristen and her grandmother came into our store. They casually browsed through the angel gifts in the front of the store before being drawn to the gallery at the back of the store.

I saw them enter the gallery, so I followed them inside as I would with any other customers. Neither had been to our store

before, nor had they ever seen or heard of the art of Andy Lakey. Both stood in awe of the room full of brightly colored angel paintings.

"We came downtown on an outing to shop at the thrift stores. Kristen saw your shop and said she had to go in and see what you had," said the grandmother.

"I had a dream about your store last night. I've never been here before, but I knew about this room. In my dream there were angels flying in here," Kristen informed us.

"Put your hands over the paintings and tell me what you feel," I requested.

Both Kristen and her grandmother did as asked.

"I feel heat," said the grandmother.

"I feel heat too, and this one tingles," said Kristen.

Kristen then looked at me with a shocked look on her face, and explained, "I just heard something weird. It was like a screech. I could hear someone trying to talk to me from inside this painting." After about a minute in this state, Kristen continued, "I saw it. Oh my God, I really saw it."

"What did you see?" I asked.

"I saw a beautiful glowing angel. It was bright with white light and had golden rays behind it. It was so bright I could hardly look at it," she answered. "Then the angel spoke to me."

"What did it tell you?" I asked.

"It said, 'Don't be afraid.'"

The emotion of the moment overcame Kristen. Her eyes welled up with tears and she began to sob and shake with emotion. I had her sit on the bench in the gallery until she regained her composure.

"It was so beautiful," she said. "I'll always remember this experience as long as I live, and I won't be afraid."

Millions of Angels for Nina

Nina had really never thought much about angels. She said she had become a "Reborn Christian" at the age of sixteen and never had anyone stress their importance to her. One summer's afternoon, Nina came to our store with her friend Rosie, and Rosie's mother. Rosie and her mother are Roman Catholics. They quickly embraced the store's angel theme. Nina, with her fundamentalist Christian background, felt a little suspicious about the store's motives.

"Are these people putting angels before Christ and God?" she would later explain were the thoughts going through her head as she first walked into the store. "Why are they praying to angels and not Jesus Christ? This really goes against what I believe in."

Nina followed Rosie and her mother into the art gallery at the back of the store. There she saw the art of Andy Lakey. She was not that impressed.

"These paintings don't look like anything," she thought to herself. "How can these be considered spiritual art?"

My wife Francesca handed two small Andy Lakey paintings to Rosie and Rosie's mother. Francesca then said, "Put your hands over your painting, close your eyes and say a prayer."

"This is really stupid," thought Nina. "This goes against everything I believe in. I've been taught not to pray to angels. This just isn't 'Christian.'"

To appease Rosie and her mother, Nina put her hand over a painting and prayed to God. "If angels do exist, please let me know their purpose," Nina prayed internally. As Nina thought these words, a vivid vision appeared to her. She saw a giant enclosure with millions of angels in it. All the angels had come to this grand room to get their assignments from God. They all had various tasks to perform. They were all there to fulfill God's purpose. This purpose was to watch over humankind.

Nina left the store with a different perspective about God, His angels and the angel store that she had visited. A few weeks later Nina had her second angelic experience. Nina worked as a professional electrician and was a member of the local electrician union. The union would give out the best assignments through a system of drawing numbers, and then the union members would wait for their number to come up. Nina's number was about to come up. She needed the money that a job like that would provide,

so it was very important to her. The day she was supposed to sign up for the job, though, Nina overslept.

When Nina got to the union office, the sign-up sheet was closed for the day. The union foreman in charge of the sign-up sheet was Nina's nemesis. He apparently did not believe women should hold jobs as electricians. He had fought her attempts to enter the union, and for the past eight years had tried to block her efforts to work in the field every way he could. Nina knew this man would not give her a break.

So, she went home discouraged and brokenhearted. She needed the job so much.

She thought to herself, "Maybe I could lie about my reason for not signing up for the job."

Then an inner voice said to her, "No, Nina that would be against your integrity. That would be a sin against God." Nina could not think of any other way to solve this problem. It was a terrible dilemma. Either go against her integrity or lose the job she so badly needed.

When Nina got home, she went into her friend Rosie's room. Rosie had purchased a painting by Andy Lakey and had hung it on her wall. Nina took the painting down, held it by its edges and prayed, "Dear God, please send your angels to help me. I need this job so badly, and I don't want to go against your will. I don't want to lie. I don't want to lose my integrity." She then

mustered up her courage and called the much-feared union foreman.

She explained, "I was late coming in today, can I still sign the sheet for my job?"

"Don't sweat it," the foreman replied, calmly and completely unlike his usual self to Nina. "Just bring in all your paperwork by Monday."

Nina is now fully committed to the power of prayer and of the existence of God's angels. She visits our angel store regularly and now has several of Andy Lakey's paintings in her home.

Into the Light

One warm April's day, I received a call from a gentleman named Mitchell. He told me he was the personal jeweler for actress and singer Shari Belafonte. Ms. Belafonte had commissioned Mitchell to produce a lavish piece of jewelry based upon the angel paintings of Andy Lakey. The piece of jewelry was to be sold at a charity auction.

Mitchell had called to make an appointment to see Andy's art at our store. He had never seen Andy's art in person and felt this experience would help inspire him to create his piece of jewelry.

Mitchell arrived about 11:00 a.m. on a Monday morning. My wife escorted him into our art gallery at the back of our store.

Mitchell was immediately entranced by the paintings. He ran his hands over one, then another, each time being amazed by the energy they poured out to him.

Francesca turned to Mitchell and asked, "Would you really like to experience these paintings?"

Mitchell nodded his head and said, "Yes, I would."

"Then, do what I tell you," replied Francesca. "Sit down in this chair and put your hand over this painting."

Francesca pulled a sixteen by twenty inch Andy Lakey painting down from the wall and placed it on Mitchell's lap. "Close your eyes and say a prayer to God," Francesca continued, as she dimmed the lights in the gallery.

Mitchell did as Francesca instructed. Francesca stayed by his side and prayed with him. As she looked at Mitchell, she noticed he had gone into what looked like a trance. After a few moments he awoke with a look of confusion and amazement on his face.

"I can't believe it. That was the most amazing thing that ever happened to me," Mitchell declared.

"What happened? What did you see?" asked Francesca.

Mitchell replied, "I was sitting in this chair with the painting by Andy Lakey in my lap. You dimmed the lights, I closed my eyes and everything became dark. I then began seeing

glowing golden flashes everywhere. Then the flashes became a solid flowing light.

"As I saw this light, I began to see white flowing clouds. These clouds surrounded me and lifted me up toward the light. As I reached the top, the light parted like a gate. I moved through the golden light and entered a place that was bathed in a blue misty light.

"The place was flowing with a solid white energy that caressed my body and touched my soul. As I experienced this, I felt I was being lifted still higher. The blue light and the white light mixed at this point to create an electric white blue, a color I have never seen before. Then white energy pillars lifted me to the top of the light. It was bright white.

"As I stood there, a human profile began to come toward me. As the profile turned, I recognized it as my deceased grandfather. He smiled as he passed by me. Then a multitude of other profiles came toward me. I didn't recognize any of the figures I saw.

"At this point, I noticed the energy of the place was changing. I saw the room's energy turn into a small circle of light. I dove into the light with my eyes closed. When I opened my eyes, I was sitting in my chair looking at this painting by Andy Lakey."

Mitchell was so impressed by his experience in the Andy Lakey art gallery that he convinced his business partner, Pericles, to visit our store the following Saturday.

When that Saturday arrived, Francesca led Pericles into the gallery. He put his hand on one of Andy's paintings, and he too had a vision of the other side.

Pericles described what he saw, "From the moment I walked into the gallery, I experienced a strange, yet peaceful, sensation throughout my body. When I placed my hands on a painting by Andy Lakey, I had a vision.

"Several years ago my cousin was in a motorcycle accident and had a near death experience. He said he saw his entire life pass before his eyes. Then, in the distance he saw a woman. She was very bright with light all around her. As my cousin approached the woman, she reached out to him. When he went to take her hand, she moved her hand away and said, 'Now is not your time.'

"During my vision, I saw that woman. If she were aware of my presence, she didn't make it known to me. I simply watched her. She was surrounded by darkness, yet a bright light shone through her and from her as she floated in the darkness. It was beautiful. I will never forget this experience as long as I live."

Things are Coming Out of that Painting

On an afternoon in May, I received a call from a woman from Illinois named Sandy. She said she was a good friend of Cheryl and Dr. Raymond A. Moody. She had a near death experience several years ago and had participated in Dr. Moody's first book, *Life After Life*. Dr. Moody was her daughter Mary's Godfather. Mary had been the flower girl in Dr. Moody and Cheryl's wedding.

Sandy and her husband own a painting by Andy Lakey. The last time they were with the Moodys, Dr. Moody asked her if she had ever experienced anything unusual happening with their painting. Cheryl and Dr. Moody both related their experiences with Andy Lakey's art.

Sandy was amazed by the Moodys' stories. After she left the Moodys' home, she began to recall some unusual things going on with her painting. She told the Moodys of her experiences, and then called Andy Lakey. During their conversation, Andy suggested she call me.

Sandy said unusual things happened from the beginning. When they brought their Lakey painting home, their Yorkshire terrier went crazy. The dog barked every time it saw the painting. Sandy and her husband thought this was very odd, but dismissed it as a problem with the dog.

Sandy hung her Lakey painting in a prominent place in their home's hallway. After a few days, she and her husband noticed something unusual. Their daughter Mary, who was in the habit of keeping her bedroom door open at night, began to close it most of the way shut. Again, they dismissed this as nothing to be worried about. They felt it might be a stage of life Mary was going through.

When Sandy and her husband returned from their visit with the Moodys, she was curious about her daughter's change in habits. The next morning, Sandy asked, "Mary, why did you start closing your door at night?"

Mary replied, "Mom, ever since you got that painting and hung it outside my door, I've been afraid."

"Afraid of what?" asked Sandy.

"Every time I look at that painting at night, I see things coming out of it mom. These things scare me. So I've started closing my door so I don't have to look at them."

Sandy was amazed by her daughter's story. She and her husband have gained a new interest in their painting. They spend time looking at it. They want to find what it is trying to show them. They also want to help their daughter see the positive messages their painting is giving them, so she will no longer fear it.

Oh My God! I Just Saw Jesus

It was a cold windy day in December, and Ventura was having its annual Holiday Street Fair. At about 1:00 p.m. all of the stores on our block lost electricity due to wind gusts that had downed power lines.

This was a day we had hoped to make money to cover our Christmas expenses. There are no windows inside our store, and it turns into a dark cave when the lights are out, even in the daytime. Francesca and I decided we would keep the store open and give "angels in the dark" tours.

As an added dimension to our tour, I offered to escort small groups into our Andy Lakey art gallery. It was nearly pitch-dark. Everyone I took through it was impressed. They could all feel the energy coming from the paintings. Many could see sparks of colors coming off the art. Many had never even seen Lakey's art in person before, but they were still amazed by the experience.

About 2:00 p.m. a woman named Betty came into the store. She had never been to our store before and had never heard of Andy Lakey, or his art. I offered to show her the darkened gallery. She skeptically agreed to see what, to her, appeared to be a stupid exhibit, "art in the dark." We entered the gallery and I pointed her to a large original painting by Andy Lakey.

"Put your hand about an inch over this painting. Some people feel something coming off them," I suggested, and Betty played along.

"Wow! I feel heat and it tingles," she said. "What makes it do this?"

"I have heard many explanations," I replied. "Some say the paintings have the spirit of God in them. Others quote 'Isaiah 10:27' in the Old Testament and say they are anointed by the Holy Spirit."

"Do they all do it?" Betty asked.

"Yes. People say they feel the same sort of things from all the paintings in the gallery," I replied. "Try this one over here," I instructed, while pointing at a painting Andy Lakey had painted of Francesca and my hands.

I led Betty to the painting. She put her hand over it and gasped, "I just saw Jesus. Oh my God, that was really weird. I've never had anything like this happen to me like this before."

"Was there anything else that happened?" I questioned. "Did you see any colors? How was Jesus dressed?"

"All I saw was His face," Betty answered.

Betty then proceeded to put both of her hands out, placing them above the painting. She explained, "He's giving me a message. Both my parents died last year. He says not to worry

about them. They're happy where they are. They are both with Him in heaven."

The Leader of the Flock

Delia, a dark-haired Hispanic woman in her early sixties, had not been to our Ventura store in two years. She was going to the party for a fifteen-year-old girl and felt she might find what she needed with us.

"I used to come here all the time with my mother," said Delia. "Since she died two years ago, I just haven't been able to make myself come back to your store since."

After finding an appropriate gift for the soon to be fifteen-year-old, Francesca suggested that Delia go with her into the gallery of art by Andy Lakey. Delia followed Francesca into the gallery. Delia had seen the art before, but was amazed by the variety of new paintings that currently hung in the gallery.

"Delia, put your hand over a painting that calls you, and tell me what you feel," Francesca insisted.

Delia found a large painting with a golden angel on it. She closed her eyes and put her hand over it, and as she did so, she seemed to go into a trance for just a moment.

When Delia opened her eyes, she began to cry, saying, "It was beautiful. It was just so beautiful."

"What did you see?" asked Francesca.

"I saw my son Ramon... Ramon died in 1990 at the age of 36, from complications brought on by AIDS. It was wonderful to see him again," she explained.

"What was he doing?"

"He was doing the most wonderful thing," Delia went on to describe what she saw, "He was flying. He was leading a flock of beautiful angels. Ramon's hair was long and curly and waved in the wind. His wings were white as snow and they grew right out of his shoulders. He was giggling, and when he saw me, he smiled. It was a miracle. It was like he was for real. I'll remember this for the rest of my life."

Delia told Francesca that Ramon's death had been very hard on her. It had cost her a great deal of money to visit him at his deathbed in New York City. When he died, she had him cremated to save money. Cremation made it cost less to bring him back to Ventura, California to be buried. When Delia returned to California, the local Catholic diocese officials refused to give Ramon a mass because he had been cremated. Delia found, to her great humiliation, that she had to hold his urn on her lap during a church service for the Catholic Church to conduct a mass for his funeral.

Delia was greatly relieved and very consoled to see Ramon happy and in heaven. She was pleased to know he was now the leader of a "flock" of angels.

The Spiritual Touch

We had experienced many unusual spiritual encounters at our store, but for a long time our encounters only included apparitions and verbal messages. The third and most scientifically provable form of contact had eluded us, physical contact with a spiritual entity.

It was about 11:00 a.m. when Eden, Nancy, Sol and Carlos arrived at our store. They were on a spiritual mission. Each of them had read my book, and all had come to see for themselves if the spirituality described in that book really existed.

Eden was from Las Vegas, Nevada. Nancy was from Orlando, Florida. Sol and Carlos had come all the way from Puerto Rico. They all had been friends for years and shared an interest in spiritual things, especially the art of Andy Lakey.

The spiritual feeling they got when they entered our store overwhelmed the four tourists. They were amazed by the vast quantity of angel gift items on our shelves. They began stacking piles of all the things they intended to purchase.

After about an hour of clearing our store's shelves, the four friends said they were ready to experience Andy's art. Francesca and I led them to the gallery at the back of our store. Once there, we had each of them run a hand above the paintings. They were all amazed by the energy they felt.

It was about noon when Francesca and I decided to treat our guests to the full psychomanteum experience. We had them stand about five feet from a large painting with two angels and many rays of light on it. I pulled down the lever that dimmed the gallery's halogen lights. They were amazed by what they saw.

"The angels are flying off the painting," shouted Sol.

"I feel like the angels are in this room with us," Eden joined in.

"This is wonderful," added Nancy.

"Are you all ready to really experience something 'mind blowing?'" I asked.

"What are you talking about?" replied Sol.

"Do you remember in my book, where I spoke of a vortex in this room?" I questioned.

"Yes I do," Sol answered.

"Well," I added, "would you like to see the area where the vortex story in my book happened?"

"We've come all the way here to see your store. Of course we want to see it," responded Sol.

All of the others nodded in approval. I walked over to the far-left hand corner of the gallery. I then motioned toward the painting Andy Lakey did of Francesca and my hands, and explained to them, "We have found that the vortex activity in this room comes from this spot."

I dimmed the lights, and then told everyone to look at the painting of the hands. We all began to experience the same phenomena. Six of us in the room saw swirling colors start to take over the front of the painting. It was like a deep tunnel leading into a long, swirling, pulsating expanse.

As I turned the lights back on in the room, Eden screamed, "Ouch! Something just scratched me."

Francesca walked over to Eden to see if she was all right. Eden pulled up the sleeve on her blouse to reveal fresh bleeding scratches on her arm. The three most prominent scratches were symmetrical, one in the middle and two a little lower on each side of it. They almost formed a cross.

"Eden, did you see anything in the vortex?" I asked.

"Yes," she replied, "and I felt a male presence."

"Have you lost any male relatives recently?" I asked.

"Yes, my father died last year."

"What was your relationship like with your father?"

Eden looked at me sadly, and answered, "We had a really bad relationship. He and my mother divorced when I was just six. I didn't see him again until I was a teenager. I always hated him for abandoning me. Maybe this is a sign from him that he really did care about me."

As Eden was leaving, she realized something amazing. During the past day on her trip she had felt very sick. Her head

ached and her stomach hurt badly. After her experience in our store, all of her pain was gone and she felt wonderful.

Two days later, Eden called our store and Francesca answered the phone.

"I know what my experience was all about," Eden excitedly proclaimed.

"What was it?" asked Francesca.

"For the past several months, I have been having a spiritual crisis in my life," she admitted. "I began to doubt the existence of God or His angels. Then I read your husband's book and I began to find a new spirituality in my life. On our trip to your store, I worried I might be disappointed with what I found. I prayed to God that I would receive a sign that He really existed when I came to your store. I guess I should watch what I pray for. That cross-shaped scratch on my arm was really a wakeup call."

Answers from God

One afternoon, I received a phone call from a woman named Martha. She seemed upset and concerned about something, but she did not directly express her feelings to me.

"I need to find your store," she told me. "I'm coming from Carson."

Carson is a town about an hour south of Ventura. I gave the woman directions to the store, and she seemed grateful.

She then asked me, "Are you Keith Richardson?"

"Yes I am," I replied.

"I read your book and it was wonderful. Now I have to come to your store and find out the truth for myself."

"The truth about what?" I asked her.

There was only silence on the other line for a moment, and then she informed me, "I have a question for God. I'll tell you more when I get there."

About an hour later, Martha and her boyfriend arrived. Martha was tall with dark hair and dark brown eyes. She told me that she worked as an administrator at a Los Angeles high school.

"Something really awful happened two weeks ago, and I've been trying to work through it," Martha told me.

"What happened?" I asked, hoping to be able to console her.

"Two weeks ago, five students from my school went to a party in Lancaster. They call these parties 'Raves.' Here young people listen to loud music, dance and take drugs. On the way home from the party, these young people took a shortcut through the Angeles Crest Mountains. Somehow they didn't make a curve on the way down, and their car went over the cliff. They were all killed in a fiery crash."

"I heard about that on the news. That was a really terrible tragedy."

"I've been to all of their funerals over the past week," she said. "Someone at the administrative office of our school district had a copy of your book. We've all been passing it around. Reading your book is the only thing that has gotten us all by."

"I'm glad the book helped you," I said sincerely.

"I've got to know more," she insisted. "I have a question for God. I've come here to see if it can be answered."

I led Martha over to the other side of the store, where my wife Francesca was standing, and introduced them to each other. Martha briefly told Francesca her story.

"I think we might be able to help you," said Francesca. "Follow me," she added.

Martha followed Francesca into the far back corner of the art gallery. There hung a three by three foot painting by Andy Lakey. It had numerous rays of light and two large flying angels on it.

"Concentrate on the angels, squint your eyes and ask God your question," said Francesca. She then went to the other side of the gallery and slowly dimmed the lights until the room was very dark.

After a moment in the darkened room, Martha began to sob. "Oh my God, I saw them. There were five of them. My questions are: Did they feel pain? And, are they happy where they

are? They were all smiling. They said they felt no pain and were very happy in heaven."

Francesca hugged Martha and they both cried. In the midst of this emotional moment, something happened that concerned me very much. Into the store walked four young people, three teenage girls and a young man. They were all dressed in black in the style of the *gothic* fad that groups of young people throughout the United States were following at the time. I began to feel more worried as the young man, who was wearing a shirt with an image of Satan on it, walked right through the store and directly into our art gallery where Francesca, Martha and Martha's boyfriend were standing.

"You just got a message from heaven, now look who's coming in," Francesca whispered sarcastically to Martha as the young man entered the room.

Martha looked back at Francesca, frowned and nodded.

Francesca then approached the youth and asked, "Have you been here before?"

"No!" he replied, appearing to be frustrated.

"Have you seen the angel art of Andy Lakey before?" asked Francesca.

Again, the young man answered, "No!"

As he looked around the gallery, Francesca noticed he appeared to be in some sort of mesmerized trance.

Francesca returned to Martha and her story of the young people killed in the accident after the "rave" party. As she did this, she noticed that the young man was looking at them with interest.

"Are you talking about the young kids who were killed in that accident on Angeles Crest Highway?" he asked.

Francesca looked at the young man in surprise, confirming his assumption, "Yes, we are."

"Well I knew those kids," he said. "I'm a big 'raver' myself. I go to lots of parties like that. I was at that 'rave' party with those guys that night. One of the people that got killed was my best friend Bill," he added. "The news media said he was on drugs when his car went over the cliff, but I was with him at the party and I can assure you he wasn't."

Martha looked at the young man and told him," I just saw your friend and the others killed in that accident. They gave me a message."

The young man looked at Martha puzzled, perhaps annoyed, "How did you see them?"

"I looked at that painting," she replied.

The young man looked at Martha like she was crazy and said, "What do you mean by that?"

Francesca, feeling guilty about judging the young man unfairly, interrupted, "A lot of people see lost loved ones in this

room. It has something to do with these paintings opening them up to their personal spirituality."

"Can I see it too?" he said, looking at Francesca.

"Of course you can," Francesca replied. "It is a gift from me to you," she added. "Look at that painting in the back of the room," she pointed toward a large painting by Andy Lakey. "Now squint your eyes and say a prayer."

The young man was reluctant at first, but with a little prodding from Francesca, he walked over and stood in the corner of the gallery to look at the painting. Francesca slowly turned down the lights. When she turned the lights on again, she noticed the young man was crying.

"I just saw Bill. Oh my God, I really saw him," he whimpered. "Bill told me he felt no pain. He had a big smile and I knew he was happy where he is. I knew this in my heart already, but it was good to have it reaffirmed. I believe in God and angels. I've even seen angels before, but I've never seen anything like this."

Martha walked over to the young man and they embraced each other and cried. We all took some time to talk with the *gothic* dressed young man that we had all misjudged. It was a major coincidence. Each had come that day from San Gabriel, a city about one and a half hours drive south of Ventura, and neither of them had ever been to our store. We were all amazed that Martha

and the young man would be brought together to have the same experiences at the same time in our gallery.

CHAPTER FIVE

Spiritual Energy Experiences

When I purchased our store's first three paintings from Andy Lakey, I had some major challenges. I wanted to sell Andy's art, but I needed art on display to be able to sell it. I expressed my concern to Andy. He suggested that I do what many of his other galleries were doing: commission "spiritual energy" paintings.

"What's a 'spiritual energy' painting?" I asked him.

"I have the gift of feeling the energy from spiritual items. Whenever I put a meaningful item behind one of my canvases, I pick up its energy and I paint what I receive," Andy replied. "'Spiritual energy' is like a lake, I reach in and grab some of it and put it on my canvas. I never know what I am going to paint. Collectors are always amazed by my results."

"What kinds of items can we use?" I responded.

"They can be almost anything," Andy replied. "They can be a photograph, a letter, a finger print, an outline of someone's hand or any other thing that means something to your customer."

At first I thought "spiritual energy" paintings were a bad idea. To me it sounded like a "grab bag" approach to selling art. I felt that it was tough enough to sell art as it was, and I did not want to try to sell paintings that customers had never even seen before.

In time, however, I learned that "spiritual energy" does exist. We have now commissioned hundreds of these paintings for our customers. And everyone who has one done is amazed by the results. The following true stories show just how real "spiritual energy" really is.

We All Walk Different Paths

Our first request for a spiritual energy painting came from a Christian group leader named Arley. He and his group lived in Los Angeles, which is about an hour from our store. They had discovered us during a spiritual retreat in Ventura. Arley commissioned an eight by ten inch painting for his group. He gave me a photo of his youth group for Andy Lakey to put behind his wooden canvas when he painted. He also gave me a note that requested that the artist create a piece of art that would enhance the spirituality of his group. I sent the photo and the note to Andy Lakey and about a month later I received Arley's painting.

I was concerned upon first seeing it. It was unlike anything I had ever seen by Andy Lakey. It contained seven tiny angel figures. Each one had a wavy line under it. To me it resembled

seven golden bugs surfing on seven wavy surfboards. The more I studied this painting, the more concerned I became. I feared that Arley and his youth group would reject the painting and ask for their money back.

I called Arley and told him his painting was ready. I tried to stay upbeat about it, but I was really concerned. The following Saturday, Arley and two of the counselors from his youth program arrived. I cautiously brought out the painting, showing it to them back side first, making sure to point out that the photo of their youth group was taped behind it.

Arley then said excitedly, "Show us the painting."

I cautiously turned the frame over to reveal the odd picture to the three men. As I did this, they did something that really concerned me. They first whispered something to one another, and passed the painting from one to the other. Then, they all put their hands over their faces and began to shake their heads.

At that moment in time, I sadly wondered why I had let Andy Lakey talk me into doing spiritual energy paintings.

"What did you tell Andy Lakey about our youth group?" Arley asked sternly.

"I didn't tell him anything," I said defensively. "All I told him, was you wanted a painting that would help the spirituality of your youth group. If you're not happy with the painting, I'll have him paint you something else."

"But we love this painting," Arley expressed happily. "We're all totally amazed. We're blown away! How did Andy know our group's philosophy? Did you tell him?"

"I don't know your group's philosophy," I said timidly. "What is it?"

"It's right here in the painting. Don't you see it?" said Arley impatiently.

"No, I'm sorry, I must be missing something."

"Every morning when we start our youth group, we tell our kids the same thing. The thing that we are amazed that Andy Lakey put on our painting."

"What's that?" I asked, genuinely surprised that this painting could convey a message important to their group.

"We all walk different paths, but we're all going to the same place, seven days a week."

I looked at the painting again, and it all came clear to me. There were seven golden angels next to wavy lines, which represented paths. They were all going to the same place. All of the little angels were heading toward the light of heaven.

Right then, a part of me began to feel that Andy Lakey had been right, his paintings did have special meaning, and he did paint with spiritual energy.

I have met with Arley many times since then. He was so impressed by the painting for his youth group that he went on to

commissioned spiritual energy paintings for his three children. He always tells me how the paintings by Andy Lakey bring ongoing peace and spirituality to his life and their lives.

The Sky Diver Angel

One day a young woman named Dorothy brought in one of the oddest photos I had ever received for a "spiritual energy" painting. The image showed someone wearing a jumpsuit falling through the air. She commissioned a painting, but was very secretive about the photo.

"This is something that has haunted me for a long time," said Dorothy. "I don't want to tell you anything about this photo. I need to know one hundred percent in my heart that Andy Lakey painted it with spiritual energy, and that you didn't tell him anything about the photo."

I sent Dorothy's photo to Andy Lakey that day and about six weeks later the painting arrived in my store. Nothing about it seemed unusual. It was only six inches by eight inches, with one medium sized angel flying upwards and what appeared to be six rays of white light coming down from heaven. Wisps of white wash floated over a powder blue background. The work was one of Andy Lakey's original 2000 angel paintings. Its number was 1,392.

When Dorothy arrived at our store to claim her painting, I asked her again about her odd photo, "You were very secretive about the photo you sent Andy Lakey. What is it anyway?"

"The photo's of me. I'm a professional skydiver," said Dorothy.

I was shocked by her revelation. Dorothy was a tall elegant woman who always came to our store in high fashion clothing.

"You're a skydiver?" I stammered in amazement.

"I'm a professional photographer and I work with skydiving teams," she said. This photo was taken of me in 1992, when I was part of a six member team." She hesitated before continuing, "One day in 1992, my team was going to make a jump. I had a personal problem come up and had to bow out of the activity. Someone else was hired to do the photography and to jump in my place. That day, the plane crashed and everyone on board was killed. I'm the only surviving member of the team."

"It's interesting that there are six rays of light on this painting, like the six members of your team," I said.

Dorothy was not impressed. "There're six rays of light on a lot of Andy Lakey's paintings. This is just a coincidence."

"Maybe you're right," I agreed.

I turned the painting over and showed Dorothy the number. "It's number 1,392," I went further, "if you add this up it comes to

fifteen, and when you add the one and the five you get six again. Don't you find this strange?"

"I don't believe in numerology," said Dorothy, becoming bored with my attempts to sell her painting to her. "You can add up numbers all different ways and they really don't mean anything."

I handed the painting to her and she placed her hand over it to feel its energy. Then she turned it over and looked at its number again. She then put her hand over her mouth, gasped, and started to cry.

"Oh my God!" she exclaimed. "The number on the painting is 1,392. Those numbers have a meaning to me. The plane I was supposed to be in crashed on the 13th of the month in 1992."

After recovering her composure, Dorothy left our store. Two months later she returned with her husband. They had come to share their appreciation.

"We want to thank you, and we want you to thank Andy Lakey for us," she said. "The painting you sold me has changed my life. Before I bought my painting, I had what they call 'Survivor Syndrome.' I couldn't sleep at night and would often start crying uncontrollably. Since I've had my painting, I've come to realize something. It was their time to go, and it wasn't my time to go.

"I want you to know something," Dorothy continued, "that painting means everything to me. Whenever I'm feeling sad or

lonely, or anytime anything goes wrong in my life, I take my painting down from the wall, feel its energy and I know I'm here for a reason. I still have a mission to accomplish in this life."

The Winking Angel

In 1973, five-year-old Keena was diagnosed with leukemia. Keena was so sick that her mother had her aunt Judy help take care of her full time. Judy really loved Keena and was very concerned about her illness. Keena lost all of her hair and so much weight that she was just skin and bones. She was too weak to even go to the bathroom alone. Keena had no appetite and could only eat a few spoonfuls of fruit cocktail at a time.

Keena called Judy "Nanny." She would always say, "Nanny, can you please stay with me? I love you."

Judy loved Keena too, and agreed never to leave her. She was the sweetest, most beautiful child Judy had ever known. She had a wonderful smile and would wink at you whenever she looked at you. This act would warm Judy's heart. Judy held Keena for hours because it was too painful for the young girl to lie down in bed.

Judy stayed with Keena every day until the little girl died two months later. This was the most tragic and heartbreaking event of Judy's life. She felt guilt, along with terrible pain. Judy thought

it was not fair that someone so young and so sweet would have to die.

This pain and guilt stayed with Judy for nearly thirty years. She felt it when she was married and when she had children of her own. Judy's heart was badly broken, but she did not share this pain with anyone.

A few years ago, Judy came to our store to watch Andy Lakey paint. She brought a photo of her niece Keena and decided to have Andy create a spiritual energy painting using it. Andy placed Keena's photo behind one of the wooden canvases he uses and began to paint. Judy stepped back a few paces from Andy's work table so she wouldn't disturb his concentration.

As she did this, she saw something she had never seen before. It appeared to be an apparition. As Judy looked more closely, she realized it was her beloved niece Keena. Keena was smiling a wonderful smile. Then she looked right at Judy and winked her eye at her.

On seeing this, Judy began to weep uncontrollably. Andy sensed that something really spiritual was occurring. He felt a tingle go all over his body and all the hair on his arms began to stand on end. Andy then began to cry as well. Judy went over to him and they both hugged each other.

Judy says that all her guilt about Keena left her that day. She finally knew Keena was happy and at peace in a better place.

When Judy received her painting with the spiritual energy of her niece, she discovered something very surprising.

When Andy brought her painting to her, he looked at it disappointedly and said, "I'm sorry, but there's a flaw on this painting. I'll paint you a new one if you wish."

Judy saw the painting and was amazed by it, exclaiming, "No! I love this painting. This painting is perfect. It's my niece Keena."

The painting had a flaw across the face of the angel. This flaw made the angel appear to be winking. Judy knew it was not a flaw at all. It was her niece Keena letting her know that she was happy and at peace in heaven.

The Black and White Angel Painting

Karen owned an angel store in Omaha, Nebraska called "Angel Treasures." In the spring of 1999, one of Karen's customers commissioned a "spiritual energy" painting. The customer gave Karen a photo of her son Johnny, who had passed away the year before of cancer. Johnny was only ten years old.

Karen sent the photo to Andy Lakey, and about six weeks later she received her customer's painting. To Karen's great concern, the painting's background was all black except for the white rays of light that came down to a silver angel outlined in gold.

Andy's paintings had been very colorful at that time, filled with violets, blues and greens. This painting, however, was very stark, colored only by black and white. Karen wondered if her customer would like such a monochromatic painting.

Karen called her customer, and she arrived at her store at 6:00 p.m. on a Friday night. Karen reached into a drawer where she kept sold paintings and produced the artwork Andy had created with the woman's son's "spiritual energy."

The woman saw the painting and gasped, "How did Andy Lakey know about Johnny?"

"What do you mean?" asked Karen.

"How did he know about the black and white?" The woman responded. "Johnny was always a big Chicago White Sox fan. Their team colors are black and white. The Make-A-Wish Foundation answered Johnny's last wish. They flew us all to Chicago to see a White Sox game."

The woman said she felt this painting was a message from her son Johnny that she should not worry about him. She now knew that he was happy and still enjoying his beloved White Sox in heaven.

Vision of Love

Lola, an elegant, silver-haired woman in her sixties from Camarillo, California, ordered a "spiritual energy" painting by

Andy Lakey. Lola gave Andy a portrait of her deceased husband, Charles, to use for the energy of her painting.

Charles had died in March of 1993 of a heart attack. Lola and Charles had been married twenty-six years and had shared a special, very loving relationship during that time. Lola wanted her painting to preserve and honor the love they had shared.

About six weeks after commissioning the painting, it was completed. Lola came to our store to pick it up. On seeing the painting, she immediately fell in love with it. The painting had two bubbles, which represent love, and three rays of light. In the center of the painting was a silver angel lined in gold.

When Lola turned the painting over, she was left speechless by the words Andy had written, "Vision of Love."

Lola began to cry. "How would Andy Lakey know this about me?" Lola questioned in amazement. "How would he know about Charles?"

"What happened?" I asked.

"It's the words he wrote on the back of the painting. Only Charles and I would know what they mean. When I took Charles to intensive care just before his death, he couldn't speak. He wrote me a note on the back of a prescription form. His last words to me were, 'No matter how long I'm married to you Lola, you'll always be my same vision of love.'"

A Glimpse of the Universe

A few years ago, Andy Lakey gave me a unique piece of art to sell on consignment at our store. The piece, titled "The Left Attachment," consisted of four small boxes with a round opening in the center of each, placed inside of a larger three-sided box. Each of the inside boxes were attached to the left-hand side of the outer box. The entire piece was painted in gold and black, textured with raised swirly lines, forming mazes around and inside of each box.

To me this was an odd piece of art. I jokingly referred to it as the communal birdhouse. Andy, though, referred to it as a meditation box, which he explained he had felt divinely inspired to create.

After having the artwork in our store for less than a week, a man named Jim, one of our major collectors of Andy's art, saw it in our gallery. He was immediately taken by the piece and purchased it. As we were preparing the piece for Jim, I mentioned the holes and how odd they looked.

"Jim, look into the holes in this box and tell me what you see," I said jokingly.

Jim, going along with my joke, bent down and looked into one of the artwork's many holes.

"Wow! That's weird," he said. "I just saw a beautiful, brilliant light. It looked like a constellation in space."

I was stunned. Jim is an engineer, and really down to earth. He loves the art, but usually is not moved by it in any kind of spiritual way.

My wife, Francesca, also looked into the hole in the box, and exclaimed, "Wow! You're right Jim. There really is something going on inside this box. It looks like a bright white light, like an angel. It's beautiful."

I looked into a few of the holes, but I didn't see anything. I assumed that Jim and Francesca were imagining what they saw. It was all great fun, but I did not think that much of the phenomena.

About a week later, Andy Lakey and I did a radio show together. During the program, Andy mentioned his meditation boxes. He casually requested, "Tell the audience about my boxes Keith."

This question really caught me off guard. I had sold thousands of pieces of Andy's art at my store, but I had only sold one box - the one that Jim purchased the week before. But, there I was, on live radio, faking an answer to Andy's question.

"Well, uh, they're very beautiful. They come in gold, silver, red and blue," I stumbled. "They're very spiritual. They give people a sense of peace."

At this point, Andy, seeing my lack of knowledge, broke in, "In 1995, I visited Egypt. While in the Valley of the Kings, I toured the tomb of Tutankhamen. In the tomb, I saw something

very unusual. Boxes made of gold and silver with tiny holes in them. I was intrigued by these boxes and asked the tour guide what they were used for. The guide informed me that these were meditation boxes. He said that King Tutankhamen looked into the holes in the boxes and claimed he could see the universe inside them. When I returned from my trip, I began to create boxes of my own, based upon those I saw in the tomb in Egypt."

I was dumb struck upon hearing Andy's explanation. Jim and Francesca had seen the same thing King Tutankhamen had claimed to see thousands of years ago, when they looked into the meditation box. Neither they nor I knew then that Andy had created his boxes with this "spiritual energy."

Over the next few months we introduced more of the meditation boxes into our store. We found, to our amazement, that almost one hundred percent of the customers that meditated with these boxes had a visual experience that ranged from seeing colored smoke come out of the box to seeing flowers to angels floating inside and much more.

I gave one of the boxes as a gift to Dr. Raymond Moody's Department of "Consciousness Studies" at the University of Nevada, Las Vegas. He reported that his students saw many amazing things, including horses, lizards and even lost loved ones when they stared into the boxes.

These Angels All Look the Same

Several years ago, Francesca and I participated in a spiritual conference in Las Vegas, Nevada. We took several paintings with us on the trip for a customer living in Las Vegas named Marilyn. This tall, thin, dark haired and fiery brown-eyed woman with high energy also maintained a booth at the conference. I left the paintings at Marilyn's booth and went over to set up my own exhibit.

About an hour later, as I passed Marilyn's booth, she approached me quite concerned. "These paintings all look the same," she stressed. "They were supposed to have been done with the spiritual energy of my three children. I don't think Andy did anything special at all. I think he just gave you three paintings at random."

I tried to reassure Marilyn, "We've done hundreds of spiritual energy paintings with Andy. Everyone always finds their meanings."

Marilyn looked at me skeptically while responding, "Maybe this was true in the past, but this time Andy has blown it. These paintings look all the same to me."

The next morning, I entered the exhibit area of the conference and I cringed as I approached Marilyn's booth. This was something really unique to me. We had never had a

dissatisfied spiritual energy customer before. I did not know how to react to it.

"Keith! Keith!" Marilyn called as I walked by. "I have to talk to you. This is really important."

I took a deep breath and asked as calmly and comfortably as I could, "What do you want to talk about?"

"I want to talk about my paintings," Marilyn replied. "I'm so sorry about how I acted yesterday. You were right. These paintings do have spiritual energy and they know who they belong to."

"What are you talking about?" I asked, confused yet curious about what had happened to change her opinion so drastically.

"Yesterday, after the conference, I went home with my three paintings for my son and two daughters. I put them all face down on my dining table and called my son to see them.

"My son came over to the table and looked at the paintings. He said, 'those two paintings are really 'dorky.' I only like this one.' He picked it up and taped to it was his name. I then called in my daughters. Each said they liked only one of the paintings. When they turned each over, their names were on them too." Marilyn looked at me and said, "Keith, I read your book and I felt the energy from the paintings. I did everything. But I had to see

this spiritual energy thing for myself before I believed it. I really believe it now."

Dr. Raymond and Cheryl Moody's Vision

As I was in the final stages of writing my first book, I was given a copy of Dr. Raymond Moody's book, *Reunions*. I was so astonished by the synchronicity between our works that I contacted Dr. Moody for a book endorsement. Dr. Moody is a psychiatrist who is famous for his study of over two-thousand cases of near death experiences. His book, *Life after Life*, is considered by many to be the most authoritative work of its type. His book *Reunions* and its theories of the ancient Greek oracle sites have changed my life.

Dr. Moody read my book and was amazed by how our two very different approaches to the Psychomanteum phenomenon came up with very similar outcomes. He happily agreed to endorse my first book and to write the foreword to this book. He also told me the following story about his wife and his experience with their painting by Andy Lakey.

Dr. Moody first spoke to Andy Lakey when Andy was working on the book, *Andy Lakey: Art, Angels and Miracles*. Andy asked Dr. Moody to write a chapter in his book. As a gift for his help, Lakey gave Dr. Moody an angel painting.

Dr. Moody and his wife Cheryl loved the work of art they received from Andy. They put it up in a place of honor in their living room. The Moodys live in a converted gristmill, built in the 1830s, and their living room is near the top of the structure. The room has a picture window that looks out over miles of forests and rivers, at night, though, the Moodys see a different view.

The Andy Lakey angel painting reflects into their picture window, producing a Psychomanteum effect. Often, during their evenings together, the Moodys would stare into their window and see the painting's reflection. One night, Dr. Moody saw something unusual, the image of the first United States president, George Washington. He thought this was too strange of an apparition to share with his wife. He worried that Cheryl would think that he had lost his mind if he told her what he kept on seeing.

So, instead Dr. Moody called Cheryl and instructed her, "Sit here and look at our painting's reflection in the window and tell me what you see."

Cheryl responded, "Raymond you're always seeing all sorts of weird things. I never see any of that stuff. It's probably just some sort of optical illusion."

"Just humor me," Dr. Moody replied. "What I saw looked pretty real to me."

Skeptically, Cheryl sat on the couch and stared at the painting's reflection on the window. After a few seconds, she firmly stated, "This is pretty dumb."

Dr. Moody, undeterred, encouraged her to keep staring, as he left the room and went downstairs to read a book. About ten minutes later, he heard his wife call to him, "I just saw something. Oh my God! I didn't believe you, but there really is something happening with that painting!"

"What did you see?" asked Dr. Moody.

Cheryl looked down and shook her head, "You're going to think I'm crazy, but I keep seeing George Washington."

Dr. Moody admitted that he saw the same thing, but had been too embarrassed to tell her. Dr. Moody and his wife Cheryl continue to see this, as well as other visions coming from their Andy Lakey painting.

Interestingly, there is a story about President Washington and a vision that he had. As he was at one of the lowest points of the American Revolution, Washington went into the deep woods to find inner peace and to reflect on the meaning of his life. There he had a vision. Washington's vision foretold of major events in American history. It showed the positive path of our nation, and how the United States would become the most respected nation in the world. This vision is said to have inspired Washington so much

that it gave him the strength and courage to endure and win the revolution.

Time and space are all relative. Maybe Dr. Raymond and Cheryl Moody's positive work in helping people deal with their grief and mortality is part of the same vision that inspired George Washington to achieve greatness in his life.

James Redfield's Angel Painting

In October of 1996, I had the opportunity to meet noted author James Redfield, while he held a book signing at a Ventura book store. Redfield is the author of a number of spiritual adventure stories including *The Celestine Prophecy, The Tenth Insight* and *The Secret of Shambala.* He also wrote the foreword to Andy Lakey's book, *Andy Lakey: Art, Angels and Miracles.*

He owns a work of art by Andy Lakey, a twenty-eight by thirty inch piece that shows eight angels going up toward eight rays of light. During my meeting with James Redfield I asked him about his painting and if he had ever had any experiences with it.

He responded, "Shortly after I wrote the foreword to his book, Andy gave my wife Salle and me a beautiful painting. The moment we hung it on our living room wall a new and powerful energy came into our home. We were even more amazed when the picture widows in our living room fogged up and the image of a heart appeared on them. Inside the heart a multitude of colors

began to pulsate. After a few moments the heart and the colors began to fade away. Nothing like this has ever occurred in our home before this or since."

Redfield feels that Andy Lakey's art is deeply moving. For him, it stimulates a new found sense of possibility and wonder. He said he based the angels in his books *The Tenth Insight* and *The Secret of Shambala* on the angelic forms that Andy Lakey paints.

CHAPTER SIX
Angelic Healings

Healings have taken place at our Ventura, California store since the first day we placed Andy Lakey's paintings on our walls. In the beginning, people claimed to be healed of back and neck pain. We also learned that the paintings and jewelry by Andy Lakey were capable of healing pets, including birds, cats and dogs. Then we saw some really significant healings of major ailments occur. These included healings from heart disease, cancer and even AIDS.

No matter how many times we see healings occur in our store or learn of them occurring elsewhere, these phenomena are always amazing. The healings help to strengthen our belief in God and His angels. We believe only God can heal, and we always give thanks to God when healings occur.

We hear of new cases of angelic healing all the time. These miraculous cures are reported from people throughout the United States and around the world. Those who are healed often find new spiritual meaning in their lives and a renewed faith in God. The

following are just a few of these miraculous events that I have learned about since we opened our store in 1995.

Bird Angels

Marcy and her husband live in Waterbury, Connecticut. When they purchased their lovebird, which they named Newton, they did not know what an excellent loving pet a bird could be. They raised Newton from a very young age. In fact, Marcy said he did not have feathers when they got him. The young bird imprinted on her and her husband and believed they were its parents. Marcy and her husband gave Newton back all the love he brought them. They both say that Newton is like a "little human."

Newton comes when he is called, wags his tail when he is happy and communicates all of his needs and his love to Marcy and her husband. They feel he is the most wonderful pet in the world.

One November morning, tragedy struck. Newton was sitting on Marcy's husband's shoulder when the bird lost his footing and fell to the floor with a loud thud. Poor Newton was knocked unconscious. Marcy ran in and picked up his limp body and gently returned him to his cage. When the bird regained consciousness, Marcy became even more concerned. As Newton sat on his perch, blood dripped down on the cage floor. She

examined the bird and found that his tongue was badly cut. He could neither eat nor drink.

Marcy and her husband were heartbroken to see their little bird suffering so much. In her desperation, Marcy remembered something she had read in a book entitled *Andy Lakey: Art, Angels and Miracles*. In this book, there was a story about a young boy who became deathly ill, and with the help of a painting by Andy Lakey, he was able to overcome his serious illness.

Marcy owned a painting by Andy Lakey and realized that she should take it down and put it next to poor Newton. She took her little ten-inch star shaped Andy Lakey painting and put it next to Newton's cage. At first, Newton just looked sadly at the painting. But as the day went on, he started to get better. The next morning, to Marcy's delight, Newton came down from his perch to drink water and eat his food. Marcy took Newton to the veterinarian later that day, he said it was a miracle that a bird could survive such a bad fall and recover so quickly. Marcy truly feels that it was the power of the angels from Andy Lakey's painting that helped save her little bird.

Lisa's Kitten

Lisa, from Camarillo, California, about a fifteen-minute drive from our store, had been collecting Andy Lakey's art for about two years when she got her little kitten Ariel. Lisa found

Ariel at a local animal shelter, and she fell in love with her as soon as she saw her.

Ariel was a silky gray striped tabby cat. She had liked to cuddle up and purr whenever Lisa picked her up. After just a few days, Lisa became concerned about Ariel's health. Ariel began getting an infection in one of her eyes. She became uninterested in her food and refused to play. All Ariel wanted to do was lie down on her bed and cry. Lisa was heartbroken to see her kitten in so much discomfort and pain. She arranged to take Ariel to a local animal hospital.

The veterinarian recommended antibiotics for Ariel's eye. Lisa got the medicine and began to administer it to the kitten. To Lisa's concern Ariel's condition worsened. After several weeks, the kitten's eye became completely swollen shut. Lisa took Ariel back to the animal hospital, where the veterinarian admitted this was a serious infection. He felt that ultrascopic surgery might be necessary to save Ariel's eye.

Lisa was very sad and apprehensive as she drove to our store. She thought about the art of Andy Lakey and how people said it had healing powers as she drove, hoping it could heal her kitten too. When Lisa arrived at our store, she came up to my wife Francesca and told her about her sick kitten.

"Do you think something by Andy Lakey would help my sick kitten?" she asked.

"We have seen a lot of healings come from Andy's art. I can't see why your kitten couldn't be healed too," responded Francesca.

Both women looked around the store and discussed the options. Finally, they decided on the perfect thing for Ariel, a silver pendant by Andy Lakey. Lisa felt she could put this on Ariel's collar.

Lisa returned to our store two weeks later with good news. Ariel's eye infection completely disappeared shortly after the silver pendant was put on her collar. Lisa said she had taken the kitten back to the animal hospital. The veterinarian was amazed at her miraculous recovery. Lisa brought in photos of her kitten before and after she started wearing the pendant. The results were truly amazing.

A Star for Baby Ashley

One day the very concerned parents and grandparents of a newborn baby girl named Ashley came to our store. The baby had been two months premature, and at that moment she was in a hospital incubator in grave condition. No one expected her to survive more than a few days longer. She weighed less than two pounds and was alive only due to the help of life-support systems.

Ashley was her parent's first child and her grandparent's first grandchild. All the members of the distraught family wrote

notes and put them on the shrine at the rear of our store. They then walked into our art gallery, where I told them about the art of Andy Lakey and some of the miracles that had happened when people came in contact with it. Ashley's grandparents decided that they had to purchase a small painting to put next to the incubator where Ashley was being treated. They bought a five by seven inch painting and, with the hospital's permission, placed it next to Ashley.

Two months later, Ashley's parents and grandparents returned to our store in a much happier state. Ashley had surprised everyone and survived. She was doing so well that she would be allowed to come home the following week.

Her grandparents were so grateful they went on to commission a spiritual energy painting for Ashley. They gave me two photos for Andy to use. One showed Ashley hooked up to the life support system in the incubator, while the other showed her in her current improved condition.

I gave the photos to Andy Lakey and told him the story that went with them. He asked me to make certain that her story was included in this book.

The Sick Angel

When Chuck purchased Andy Lakey's miniature angel paintings for his grandchildren, he had no intention of having

spiritual events or miracles occur. Upon being asked why he was buying the art, Chuck responded, "I only care about Jesus. I want my grandchildren to find the love of Christ in their hearts too. I really don't care about the value of this art or the celebrities who own this art. I just want these paintings to help confirm the Christian faith of my family."

When Chuck brought the paintings to his daughter Diane's house, he was surprised by the unusual events that began to occur. Chuck put the two paintings he had purchased for his grandsons Kevin and Kyle on Diane's dining room table. He and Diane then went into the living room to talk. A few moments later they heard Diane's three-year-old son Kevin carrying on a conversation in the dining room. When they went in to see who Kevin was talking to, they found him holding one the Andy Lakey paintings in his hands and conversing with it.

"Jesus," he said, "I love you Jesus. You're beautiful Jesus. What's that light around you?" He pointed at the little painting as he asked this direct question.

Kevin was so excited about what he had seen that he took the painting off the table and tried to show it to his dog that was sleeping on the kitchen floor. Diane took the valuable little painting from the small boy and put it back on the table.

When she did this, she unintentionally turned the painting over. At this point she noticed something that really surprised her.

"That's odd," she said to her father, "Andy Lakey wrote Kevin's name on the back of this painting. How would Kevin know this painting was his? He can't even read yet."

By this time Kevin had discovered Kyle's painting on the other side of the table. Andy Lakey had written Kyle's name on the back of this painting. Kevin picked it up and began to talk to it. "Poor angel," Kevin said sadly, "Angel sick, angel fly away. Angel fly away."

Diane and Chuck were awestruck. Diane's six-year-old son Kyle had been sick with chronic asthma since he was a baby. Kyle had been to the hospital nearly every month for the past five years for this disorder. The doctor's diagnosis of Kyle's condition was discouraging. There was little hope for Kyle's condition to ever improve.

Over the next few months, Diane realized something amazing was occurring. When I called her to get the details of this story, she told me, "I am a Christian and I'm really not into all the miracles that the Catholics are always talking about, but something wonderful has happened to my child that I can't explain. Kyle's doctor can't explain it either. Since we got Andy Lakey paintings in our home, Kyle's illness has completely disappeared. We've had rain, wind and even the foggy conditions that often bring on Kyle's asthma. But Kyle hasn't had one single asthma attack. Those paintings that my father brought for my sons have increased my

faith in Jesus and His angels. They have also taught me that with faith in Jesus miracles really do happen."

Angel in the Light

Joey had already been a customer of our store for several years when he came by on a busy 4th of July afternoon. Joey was usually happy when he visited our store, but this day he seemed to be on a mission.

"I've come to buy my Andy Lakey painting," he said. "I've always wanted one and I have saved up my money and will buy one today."

Joey looked around the gallery of Andy Lakey art in the back of our store for nearly an hour. He just could not make up his mind. I noticed that Joey would take a small painting off the wall on the left hand side of the gallery, carry it around with him for a few minutes, then put it back on the wall.

After Joey took the painting off the wall for the fourth time, I took him to the side and said, "I think that's your painting Joey."

"How do you know this?" Joey asked.

"I've seen this happen a lot here," I informed him. "The paintings seem to know who they belong to, and this one seems to have chosen you."

"I really can't decide on which painting I want," protested Joey.

"Trust me, this is your painting."

"I don't know if it's my painting or not," said Joey.

"Look Joey," I explained, "I am positive this is your painting. I want you to take it home, live with it a few weeks, and if you then decide it's not your painting, bring it back and I'll give you all of your money back."

"Well, I guess if you put it that way, I have nothing to lose, do I?"

"That's right," I said. "You have nothing to lose and everything to gain."

Joey purchased the painting and left the store. About an hour later, I received a phone call from him. I could tell from the tone of his voice that he was very excited.

"Keith! How did you know that painting was mine?" he asked.

"Well you kept taking it off the wall and carrying it around the gallery with you."

"But Keith, it really is my painting!" Joey shouted.

"What do you mean by that?" I asked.

"Well, as soon I got home, my telephone rang. It was my mother-in-law. She lives in a trailer home in the desert near Mammoth Lakes, California. She told me that her air-conditioning system broke and it was one hundred and four degrees out. She has diabetes and was really hot and sick. I asked her what I could do

for her. She said, 'Pray for me Joey. I think I'm going to die out here.'

"After I hung up, I got a great idea. I'd test the Andy Lakey painting that I bought from you today. I took the painting off the wall, put it on my lap, and said, 'God, please send this angel to help my mother-in-law. She's really hot and sick, and needs your help."

"Did something happen after that?" I asked.

"You won't believe what happened next," Joey continued. "About twenty minutes after we spoke, my mother-in-law called me again. She asked me, 'Joey, what did you do?' And, I told her, 'I prayed for you. Why do you ask?'

"And then she said, 'Right after we hung up, the sky started to turn black and fill with clouds. Then there was thunder, lightning and hail. The hail came down for several minutes; there were four or five inches of it. Then I noticed something really strange. It had cooled down. I looked at the thermometer in my kitchen. It had fallen from one hundred and four to sixty-four degrees.' She said she began to feel better right away."

"Joey," I interrupted, "what you're talking about sounds like something that would be attributed to Ariel, the archangel."

"Who's Ariel the archangel?"

"He's the angel of thunder, lightning and hail."

"How do you know this?" asked Joey.

"I've worked in this store and studied angels for over half a decade. I know a lot about angels."

"Well that's very interesting," Joey replied unimpressed. "I'll talk to you more later I guess."

About one hour later Joey called me back again. This time he was even more excited than before. "Keith! The weirdest thing just happened. I just had to share it with you."

"What happened this time?" I asked.

"Well," continued Joey, "I was so excited about what had happened with my painting that I told my neighbor about it. I then mentioned what you said about Ariel the archangel. She looked it up on the Internet. Just as you said, he is the angel of thunder, lightning and hail. Then she told me something that I didn't know, the name Ariel means 'In God's light' in Hebrew.

"She asked me if I knew the name of my painting. And then I said, 'I think it's, 'Angel in Flight' or something.' I was really shocked when I returned home, took my painting off the wall and saw its name. Andy entitled it 'Angel in the Light.' You were right Keith, this really is my painting."

Annie's Special Painting

Annie, a seven-year-old girl from Summers Point, New Jersey has been battling the symptoms of a brain tumor for the past two years. The diagnosis was a grim report for her family. They

tried everything medically possible to slow the malignant tumor in her brain. Nothing seemed to work. The tumor kept growing.

Out of desperation, Annie's grandparents, who live in Wallingford, Connecticut, commissioned Andy Lakey to paint an angel painting with Annie's spiritual energy. They provided Andy with a photo of Annie. Lakey placed the photo behind the canvas when he painted her painting.

When Annie's painting was completed, about two months later, her grandparents made a special trip to New Jersey to give it to her. Annie loved her painting. She placed it in a special place over her bed, where she could see it and touch it.

Almost immediately after receiving her painting by Andy Lakey, Annie's condition began to improve. The tumor actually started to reduce in size. At Annie's quarterly MRI screening the doctors were astonished to find her condition markedly improved.

My Eight Angels

Joanne had never heard of Andy Lakey or his art. For months, her friends had told her about it and even given her videotapes and articles about Andy Lakey, but Joanne just was not interested.

One evening, Joanne's friend Elaine invited her over for dinner. Elaine had an angel painting by Andy in her home and loved to share the peace and comfort it gave her with others. That

night, Elaine showed Joanne a video that explained about Andy Lakey's near death experience and his mission to paint two thousand angel paintings by the year 2000.

As Joanne watched the video, she kept looking at Andy's painting that hung on Elaine's living room wall. The more Joanne looked, the more she felt connected to the angels and for the first time in her life, she felt their power.

The next day, Joanne visited her sister Barbara, who had recently been diagnosed with breast cancer. Joanne told Barbara about the video that she had seen the night before about Andy Lakey. Barbara told Joanne that she was reading a book called *Touched by an Angel* by Eileen Freedman. This book included the story of Andy Lakey in it.

Barbara got the book out of her bedroom and read the part about Andy to Joanne. In the back of the book they also found the names and addresses of many people mentioned in the book. To their surprise, they found that Andy Lakey lived in the same small town that Barbara did. Even more surprising to the women was that the hospital that Barbara worked at had two of Andy's large paintings. She had walked by them every day for over a year.

As more and more coincidences occurred in her life around Andy's art, Joanne decided she had to buy one of Andy's paintings. Joanne is not an art collector and had never purchased a piece of original art before. She, however, felt driven to purchase

an angel painting. She wanted her painting to have eight angels on it. This would represent her mother, father, her five brothers and sisters, and herself. She hoped that her painting could be a physical representation of her family, which would live on through life and death. She felt this painting would connect her family in a timeless union that could not be broken. Somehow, Joanne felt that Andy would understand her needs and would approach this painting with compassion and spirituality.

Joanne commissioned her painting at a store in Murrieta, California and then returned to her home in San Diego, California, about an hour away. On returning home, she wrote Andy a letter, telling him why she wanted her painting. She also told him of her sister Barbara who had breast cancer. She sent Andy a picture of Barbara along with the letter.

Joanne expected to wait as long as two months to receive her painting, but in less than a week, the art dealer called and told her that the painting was ready. The dealer told Joanne that Andy had received her letter, and said that he had felt compelled to paint. Joanne was in shock, but this only confirmed to her that buying her painting was the right thing to do. She felt that Andy had put her order ahead of all the others, and had worked all weekend to complete her painting.

Joanne's painting depicted the eight angels that she had requested. At the top were two large angels holding hands. Each

angel had a swirl in its body going a different direction. She felt these angels represented her mother and father.

Joanne believed that the other six angels in the painting represented her brother, her sisters and her. Of these angels, five had swirls going one direction and one had swirls going the other direction. These, she felt, represented her and her four sisters and her one brother respectively.

Joanne believed her painting was perfect in every way, and loved it very much, but it never seemed to fit in her home. She just could not find a place to hang it. Her husband Victor would ask her when and where she was going to hang it, but Joanne just could not give him an answer.

A month after getting her painting, her sister Barbara's fight with breast cancer took a turn for the worse. Everyone in the family began to get very concerned. When Joanne visited her sister, she realized why she could not find a place in her house for the painting. It was not supposed to be in her house, it was supposed to be in Barbara's house.

Barbara had a blank space on her bedroom wall. She had never found the right thing to put there. Joanne knew it had been waiting for her "Eight Angel" painting by Andy Lakey. Joanne took the painting to Barbara's home and hung it on her bedroom wall.

At first, Barbara's cancer did not get better. The disease moved to her bones. She now had cancer from her skull to her femur. Barbara said she had the most pain in her spine. She often could not sleep at night due to this pain. Barbara said she would look at Joanne's angel painting when she could not sleep. This, she said, would calm her down and give her the strength and encouragement to go on.

Barbara's health deteriorated as the cancer continued to spread through her body. Finally, her doctor gave the family the sad news. Barbara had only a few weeks to live and they should all say their good-byes to her. All of Joanne's friends and family members began a prayer vigil. They did not believe it was Barbara's time to die.

At this desperate time, Barbara was accepted into an experimental program at the UCLA Medical Center located in West Los Angeles. This program was designed for cancer patients who had not responded to other treatment programs. Barbara had an oxygen tube put in her nose, was given twenty-four hour care and could not leave the house without a wheelchair. Barbara continued to be in extreme pain and was treated with numerous drugs, including morphine.

Eight treatments later, a miracle happened. Barbara's cancer began to shrink. She soon was off the oxygen and out of the wheelchair. Joanne feels that Barbara's guardian angels are

guiding her down the road to recovery. She also believes that Andy's angel painting and the constant strength it gave Barbara played a big part in making this miracle happen.

Lucille's Blessing

One afternoon, Andy Lakey called me and said I should contact a man named John. Andy explained that John was the brother of the landlord of his Santa Barbara art studio. John had recently visited Andy's studio with his brother. Andy had given him a miniature angel painting for his wife who was gravely ill.

I called John as soon as I finished my call with Andy. John told me his wife had been sick for a long time. She had not spoken since her second stroke several years earlier. He informed me, "I recently had the opportunity to meet artist Andy Lakey in his new studio. We talked about many things. Then I told him about my wife, Lucille. It's so sad to see her in her condition. I told Andy about Lucille's strokes and he gave me a miniature angel painting for her. Andy said, 'Put it under her pillow. It could give her some peace.'

"I took the painting home, but soon realized I couldn't put it under Lucille's pillow," John continued. "She moves too much, and it would fall to the floor. So, I found a clear glass votive candleholder and put the painting inside it. You know, even

without a candle, the votive seemed to glow when I put the little painting in it.

"As I was about to leave the room, I heard something that made me think I was dreaming. I heard a voice say, 'Come here! Come here!' It was Lucille she was speaking for the first time in several years. I ran to her side and hugged her. She has begun to speak more and more since then. She now tells our dog to stay."

When John took his wife to church shortly afterward, she said, "I'm blessed."

John says he believes in angels. He believes that they are sending him God's messages through his wife Lucille. He is grateful to Andy Lakey for opening up his heart so he could receive these messages.

What's Happened to Olivia?

One warm summer's day, a Native American mother named Margaret, her daughter Julie, and Julie's three children arrived at our store. They had come from the Pechanga Indian Reservation in Temecula, California. Margaret and Julie had read my book, which they had purchased at a Temecula bookstore. They were impressed with the miracles it described and felt with all the problems they had in their lives, they needed to visit our store and see Andy Lakey's art for themselves.

Julie had been having problems at work, trouble in her marriage, and she was not feeling well physically. When she entered the store's gallery of Andy Lakey paintings, she was overcome with the spiritual feeling of her surroundings. She did not know why, but she started to cry. My wife, Francesca, saw Julie crying and put her arm around her. Julie was usually uncomfortable when people hugged her, but with Francesca it was different. She did not mind at all. She felt good and spiritually uplifted. For the first time in a long time, she felt happy.

Julie's seven-year-old daughter, Olivia, had been having problems ever since she started school. She had a short attention span and would not conform to the classroom rules. Her family had made many visits to the school for conferences with Olivia's teacher, the school principal, several therapists and a psychiatrist. All who they spoke to recommended that Olivia be put on medication for her attention deficit disorder.

While her grandmother, Margaret, was putting her hand over a painting by Andy Lakey, Olivia came up behind her and touched a small painting by Andy Lakey hanging on the wall at her level.

"Ooh! That painting zapped me," said Olivia.

"What did you feel? What happened?" asked Margaret.

Olivia refused to answer. She just sulked away and seemed to escape to her own separate world. Julie and Margaret were

amazed by what had happened, but did not give the matter much further thought.

Two weeks later, Julie went to Olivia's parent-teacher conference. Julie dreaded the possible outcome. These were always emotionally draining and there just did not seem to be any good solutions to Olivia's attention deficit problems. To Julie's relief, there was good news this time.

"What's happened to Olivia? She's really changed," Olivia's teacher told Julie. "When Olivia was asked to share in front of class, instead of turning away and sulking, she gave the most elaborate talk about an angel store she visited. She just couldn't stop talking about her experiences there."

As time went on, Olivia's teacher continued to praise how amazingly well she was doing in class, from participating to doing well in all of her subjects. Olivia's family could also see improvement in her homework and her new attitude about school.

Several months later, Olivia and her family returned to our store. Olivia's mother told us that Olivia had confided in her that she had seen an apparition of her deceased grandparents holding hands. She felt this was the event that changed Olivia's life.

An Angel for Mathew's Eye

Mathew is a ten-year-old boy from Northern California who loves angels. His mother says that he, like all ten-year-olds, is full of energy. He never walks - he runs.

One afternoon, Mathew was playing in the living room with his mother Patricia when he smelled cookies baking in the kitchen. He immediately got up and ran to the kitchen door to get one of the freshly cooked treats. As he came to the door, his godmother Carolyn opened it. The door hit Mathew hard, right in the eye. He fell to the floor in pain. Carolyn picked the child up and put him on the couch in the living room. Patricia ran to the bathroom to get an ice pack for Mathew's hurt eye.

As Carolyn came to Mathew's side to comfort him, he told her, "I don't need an ice pack. What I need is an Andy Lakey painting. My mother read me a book about Andy Lakey and I know that his painting will help my eye."

Carolyn was surprised by the request, unsure what to do, she asked Patricia, "Do you have an Andy Lakey painting?"

Patricia nodded yes. She then produced a small two and one-half inch by three-inch painting from a drawer.

"Put it on my eye!" pleaded Mathew.

Patricia did as he asked.

"That's much better," said Mathew. "Mom, that book you read me was right. These paintings do heal."

After about an hour of holding the small painting on his eye, Patricia and Carolyn were both amazed to see that Mathew's eye did not swell up and there were not any bruises. It appeared as if Mathew had not hit the door at all. Mathew said he felt fine and resumed his fast paced ten-year-old life style.

A Distant Healing

Lynn was excited and very happy to be going back to visit her family on the island of Mindanao in the Philippines. She was most pleased by the fact that on this trip she was bringing a gift to her mother that would help to increase the awareness of spirituality for her entire family.

Lynn had purchased a miniature painting by Andy Lakey one day earlier. She knew her mother would love it, and all of her family members would be very impressed. As she was about to board her airplane, Lynn made a call to her mother's home to ensure that she would send a driver to meet her at the airport. When she called, Lynn learned the grave news that her mother had been in a serious accident.

Lynn's mother, Helena, despite being eighty-four years old, was still active in the Philippine government according to Lynn. Her duties involved serving as director of a national agricultural program. While on a trip to a highland region earlier in the day, Helena was hit by a strong gust of wind and swept down a small

ravine. She hit hard on a rocky crevice and was in excruciating pain. She was taken immediately to the emergency room of a local hospital. Lynn was told everyone feared for the worse. She was very old and it was certain she had broken many bones. Lynn's driver was going to take her directly to the hospital when she reached the Philippines.

Lynn was in shock as she boarded her plane for the twelve-hour flight to the Philippines. She knew how active her mother was, and worried that if they confined her mother to a wheelchair, it would kill her.

As her plane reached cruising altitude, Lynn remembered her little Andy Lakey painting that she had in her purse. She reached in and got it out. She had heard of the many miracles associated with the art and decided to test it out. Lynn put the little painting on the palm of her hand, closed her eyes, and said a prayer, "God, please heal my mother. Don't let her bones be broken. She is doing so much good for my people in the Philippines. Please let her continue her work."

When Lynn arrived in the Philippines, her mother's driver greeted her. She got into the car, but found to her surprise that he was not taking her to the hospital to see her mother. He was taking her to her mother's home. When Lynn entered the house, she was surprised to find her mother in good spirits, sitting in a wheelchair.

"Mother, I thought you were in the hospital."

"Well, I felt much better, so they discharged me," Helena explained.

"When did you start to feel better?" asked Lynn.

"It's funny you would ask that, about twelve hours ago I felt the pain in my body totally vanish."

Lynn was amazed. She knew that was exactly the time she started praying for her mother while holding her painting. Lynn asked her mother, "What is the prognosis of your condition?"

"They're still checking my X-rays," answered Helena. "They'll get me that information in a couple hours. In the meantime, they are making me stay in this wheelchair."

Lynn reached into her purse and pulled out her miniature painting by Andy Lakey, and asked, "Do you know what this is?"

Helena shook her head no.

"This is a painting by the world's most famous angel artist, Andy Lakey," Lynn continued. "These paintings can heal. In fact, I prayed for you with this painting in my hand twelve hours ago." Lynn then handed the little painting to her mother, "Put it in your hand and pray for healing."

Helena did as Lynn instructed. Two hours later, the hospital called with the results of Helena's X-rays. No broken bones, there was just a single hairline fracture in her hip.

Helena recovered fully, crediting her miraculous healing to the power of prayer, and the wonderful art of Andy Lakey.

In a Dream

Maria, a dark eyed Hispanic woman in her early thirties awoke from a very unusual dream one evening. It was so strange, that she wrote it down.

In her dream, she and her boyfriend were driving around the city of Ventura, California. They couldn't find a place to park their car. At last, they found a spot on the right hand of the street about a block before the San Buenaventura Mission.

As Maria got out of her car, she noticed something wonderful in front of her, an angel store. The lights were on, but the door was closed. Maria opened the door and entered. There appeared to be no one inside. She saw all of the wonderful angels and felt a peaceful presence. She called out, but no one answered. She appeared to be all alone.

At the same time, Maria saw her boyfriend, Mark, waiting outside the door. "Come out of there!" he shouted. "You're going to get in trouble. You're not supposed to be in there."

Maria paid no attention to Mark. She continued to wander through the wonderful store. She walked through a doorway at the back of the store into an amazing room full of beautiful artwork. The art was brightly colored and had symbols on it. They looked like primitive rounded crosses with rays of light reaching down to them. She marveled as the paintings appeared to change colors before her eyes and glow. She had never seen anything like these

paintings before. As she gazed upon them, a feeling of warmth and peace came over her whole body.

Maria left the room full of art and returned to the front of the store. There, near the store's entrance, to her left-hand side, she saw a doorway covered by a curtain. Maria pulled the curtain aside to reveal a blinding bright golden light. At first it was painful to look at the light, but as her eyes adjusted she saw, to her wonderment, a large beautiful angel.

The angel gave Maria a message, "Find this store and you will be healed."

At this point, Maria woke up.

Maria called Mark the next morning and told him her dream. He was skeptical, "It was only a dream, why are you making such a big thing out of this?"

Maria pleaded for Mark to take her to find the wonderful store she had seen in her dream, insisting, "I know there's something there I have to see."

As they drove into downtown Ventura, Mark said, "I'm sorry Maria, but I've been down this street a million times and I've never seen the 'angel store' you're talking about."

"It seemed so real. We've got to find that store, I know it really exists," Maria persisted.

Then to their shock, they saw a crowd gathered at just the spot Maria saw in her dream. They did not know it at the time, but

it was artist Andy Lakey, painting abstract angel paintings on the sidewalk. They were in front of the angel store.

As if by magic, the only empty parking space in the city of Ventura was in front of the store. As he came to the realization of the miracle, Mark became overwhelmed by emotion. His voice cracked and a tear ran down his face as he said, "It's true, oh my God! It's really true. Your dream was real Maria."

They walked through the crowd and entered the store. To Maria's amazement, it was very much like the store in her dream. The only thing missing was the door on the left-hand side of the entrance, where Maria had seen the angel. Maria found my wife Francesca, and told her the story of her dream and how it led her to our store. Francesca was amazed.

On her second visit, she told us, "I've got to tell you the rest of my story. Before I had my dream and before I visited your store the first time, I was very sick. I suffered from 'Traumatic Stress Disorder.' The worst thing about my illness was my ongoing panic attacks. These attacks were destroying my life and making me miserable. It's been over three months since my dream and my first visit to your store. All symptoms of my illness have disappeared. I'm feeling better than I've felt in my entire life. It's a miracle. I want to thank you for that."

Francesca replied, "Don't thank me. Thank God and His Angels. They're the only ones who really heal us."

Jan's Healing Painting

Jan was a teaching assistant at a major university. She was such a great resource to the professor she worked for, that the professor asked me to bring him a painting by Andy Lakey so he could purchase it as a gift for her.

We searched our stock and found just the right painting. It was gold and cream in color with two rays of light coming down with one large silver angel outlined in bright gold. Jan loved the painting the moment she saw it. We had her run her hands over it. As she did, her face turned pale and she said, "My God, I feel something. I've never felt anything like this before. It's tingling. It's hot."

Jan then became uneasy, and explained that she felt faint. Francesca and I had her sit in a chair and concentrate on grounding herself.

"We've seen people fall straight back on the floor when they put their hands on these paintings," I told her. "You've got to be careful."

Jan had the professor run his hands over the painting too. He shook his head and said, "Oh my God, I feel it. I've never felt anything until now. This is really amazing."

Jan knew, after this, that her painting was very special. She swore to herself that she would use this painting to assist her to help others. A few weeks later, Jan had her first opportunity to test

141

her painting. Her friend Mandy, a teaching assistant from another department at the university, was having serious problems on the job. Her department head had reprimanded her and put her on probation. Mandy thought the actions of her academic department head were unfair and unwarranted. It affected her whole life, her concentration, her thinking and even her health. The morning that Mandy called Jan about her dire predicament, she was so distressed that she said she had thrown up blood. Mandy felt her situation was hopeless.

Jan thought about all of Mandy's options at the moment, but the only option that Jan kept coming back to was to use her angel painting by Andy Lakey to help her. "You're probably going to think this is crazy," Jan said, "but there is evidence that the art of Andy Lakey has helped people overcome situations like yours. Would you like me to bring my painting over to your office so we can give it a try?"

"I'm desperate, I'll try anything at this point," Mandy replied.

Jan brought her Andy Lakey painting across the campus to Mandy's office. Jan had never used a painting to heal someone before and she really did not know what to do, so she improvised.

Jan instructed her friend, "Mandy, take this painting into the room next door, put it on your lap and meditate on its picture."

Mandy meditated for about half an hour. Afterward, she said she felt much calmer, very peaceful and better able to concentrate. "Jan, you're not going to believe what happened to me," Mandy said. "I saw something wonderful."

"What did you see?" asked Jan.

"As I looked at your angel painting, I saw the arms of the angel turn into hearts. Then, they turned into circles and began to spin. After a few moments the angel's head separated into two parts. Then I heard a female voice say, 'This is not a lesson. This is just a stepping stone.' I also had a visual image of my department head apologizing to me."

Less than a week later, Mandy rushed breathlessly to Jan's office, "Jan, there's something I have to tell you. Everything the angel on your painting predicted has come true. My department head apologized to me this morning. He also revoked my probationary status and removed his letter of reprimand from my file."

Jan knew Andy Lakey's paintings had healing power. Mandy's experience has confirmed her beliefs even more.

Danny's Miracle

In February of 1997, two of our regular customers arrived with their cousin. The cousin came into our store looking like a human skeleton. He said his name was Danny and was in the final

stages of AIDS. They had checked Danny out of a local hospice program and then brought him to our store. This was their last ditch effort to bring him comfort, or perhaps a healing.

Danny staggered into our store, held up only with the support of his cousins. He had a cane in one hand and an IV hooked up to his other. They carefully guided him through our store into the gallery of Andy Lakey art.

Francesca and I had seen a lot of sad situations at our store, but this appeared to be really pathetic. "He looks like he only has a few more days to live," I whispered to my wife Francesca, feeling genuinely sad.

"Yes, it seems cruel for them to take the poor man out of his hospice program. They should let him go in peace," agreed Francesca.

Danny's cousins took him to a three by four foot painting hanging on the gallery wall and told him, "Pray!"

Danny put his hand on the painting, closed his eyes, and appeared to do as told. Francesca and I watched on in sorrow as his cousins propped him up and allowed him to be near the painting.

"Tell God you want to be healed," one of the cousins said in desperation.

I took Francesca aside and whispered to her, "This is all really futile. No one has ever been cured of AIDS. These guys are living in illusion."

Three months later, in May of 1997, Danny and his two cousins strolled back into our store. Rather than being on the brink of death, Danny now appeared to be healthy and strong and had put on thirty or forty pounds. He attributed his new found health to his encounter with the art of Andy Lakey. I asked him to write down exactly what had happened to him. This is what he wrote:

"I was diagnosed HIV positive in 1988. In January of 1997, my condition worsened when I contracted Meningitis my weight dropped from 175 pounds to 130 pounds in less than 30 days. Everyone thought I was going to die. Out of desperation, my cousins brought me to your store to experience the art of Andy Lakey. They told me to put my hand on a painting and pray. I did what they told me. Less than two months after this encounter with the art my condition stabilized and my weight climbed back up to a happy 195 pounds. All of my doctors and hospice care workers are dumbfounded. I want you to thank Andy Lakey for helping me open my heart to God so I could be healed."

CHAPTER SEVEN
Heavenly Gifts

Of all the wonderful things God brings us, our children rank among the top of the list. We play with them and we share our dreams with them. In time, they even share their dreams with us. Children are a great gift and we must thank God for all of our gifts each day.

Many Eastern religions teach that children choose their parents prior to their birth. In this way, the child's soul is able to learn new lessons and the parent's soul is also taught the things it needs to learn.

The following stories tell how the paintings by Andy Lakey have opened "doorways to heaven" for people who have been told of limitations on their ability to become parents by authorities and medical experts of our society. All people whose lives have been touched by Andy's art find that there are many things the bureaucrats and scientists cannot do, but there is nothing God cannot do.

Alan's Fertility Painting

In December 1998, NBC's *Today Show* featured Andy Lakey's New York art opening. The lead into Andy's segment was an amazing story told by a reporter named Glen. A woman named Beverly, whom Glen met at a cocktail party the evening prior to the program, had told Glen this story.

There was a painting by Andy Lakey that was being sent to help people throughout the United States. A man named Alan, who lives in California, owns the painting and sends it on loan to all that need spiritual and physical help. The most common thing she knew about was that the painting was capable of healing infertility.

Beverly learned about this painting from Alan's sister Tina. At first, Beverly was skeptical. She neither understood nor believed a painting could heal someone. She thought it was all "really silly."

Tina and her husband had desperately wanted to have a child. They paid thousands of dollars to fertility clinics with no success. When Alan heard about their plight, he sent them Andy's angel painting. Tina became pregnant in just a few months after receiving the painting. To her delight, she did not have just one child, she had twins.

Beverly had one daughter, but wanted another child. She and her husband tried in vain to conceive. Finally, they went to a fertility clinic. They learned that although Beverly was only in her

late twenties, she had no eggs left in her ovum. Her reproductive system was fine, but her only way of conceiving was through invitro fertilization, using the egg of another woman.

Beverly was still skeptical, but felt she needed Alan's Andy Lakey painting to get her through. She called her friend Tina and asked to borrow Alan's painting. Tina had her brother send the painting to Beverly's home in New Jersey. Upon receiving the painting, Beverly felt a sense of peace and hope overcome her. She knew something very positive was about to happen.

Beverly began to think of who would be the best person to use as an egg donor. Then, the thought struck her like a flash. Her sister Margaret was the perfect person. She was her same blood type and they both looked very much alike.

Beverly immediately called Margaret and told her of her intentions. Margaret was thrilled at the prospect of helping her sister conceive. The doctors, however, were not so thrilled by this idea because Margaret was diabetic. This, they said, could have grave consequences on Margaret's health if she underwent the operation to donate eggs to Beverly.

Beverly and Margaret discussed the pros and cons of this procedure for several weeks and finally decided to take the risk and have Margaret donate her eggs. Beverly told Margaret about the painting by Andy Lakey and how it had helped heal people throughout the United States. She loaned the painting to Margaret,

and she took the painting with her to the hospital and put it next to her bed. To everyone's relief, the operation was flawless. The doctors were able to obtain the eggs from her ovum and Margaret came out of the operation in perfect condition.

After the operation, Margaret gave the angel painting back to Beverly. Then, to everyone's amazement, Beverly became pregnant immediately after her first invitro fertilization procedure. The doctors told Beverly that this was a very rare occurrence. Few, if any, women become pregnant after just one invitro fertilization procedure. Beverly gave birth to a beautiful baby girl nine months later, and had no complications.

Alan's Andy Lakey painting continues to help people with physical and spiritual needs. Beverly says she knows that the painting has crossed the country at least three times, and had even been to the state of Alaska. She feels that all that borrow the painting open their hearts to God and find healing and increased spirituality in their lives.

A Child from Heaven

Tina, a health care worker, and her husband Jamie, a high school teacher from Mifflin, Pennsylvania, located near Pittsburgh, Pennsylvania, desperately wanted to have a child. They had been trying to have a baby for almost four years. They had nearly exhausted all the resources the medical establishment had to offer.

Tina had taken hormone shots and followed many fertility procedures. Both had received much sexual counseling, but nothing was working.

After spending a depressing Christmas with Tina and Jamie, Tina's father, Ed, purchased a copy of the book, *Andy Lakey: Art, Angels & Miracles,* at a local bookstore. He hoped that this book would raise his spirits. Ed read the book and put it on his shelf.

During May of the next year, Tina and Jamie came to Ed's home wanting someone to talk to. They were desperate about having a baby. They felt their lives were slipping away. They felt there was no hope. No matter what procedures they used, they would never have a child.

After Tina and Jamie went home, Ed thought of Andy's book. He got it off the shelf and started to browse through it. As he did this, he realized there was a story in the book about someone becoming pregnant shortly after purchasing a piece of Andy Lakey's art, following many years of unsuccessful expensive medical intervention. The idea seemed silly at first, but as Ed gave it more thought it seemed his only alternative. He needed to purchase one of Andy's angels for Tina and Jamie. Ed gave his book to Tina to read, and she loved it.

When they got together the next day, Ed asked Tina, "Would you like to own one of Andy Lakey's paintings?"

Tina's eyes brightened at the prospect of owning such magical art, and answered, "I'd be thrilled to own one."

Ed searched all over for a place to purchase one of Andy's paintings. He finally found an art gallery in Chicago, Illinois that carried the art. Ed visited the gallery and purchased one of Andy's paintings.

The unique piece of art consisted of a three by four inch angel painting attached to a small frame with Velcro. The Velcro would allow the painting's owner to display the art in his or her home, while also being able to take it with them by pulling the little painting from the Velcro and out of the frame.

Tina's painting arrived in October of 1998. Tina and Jamie loved it and put it in a place of honor in their home. At first nothing happened, and they settled into their normal routines.

As Christmas again approached, Tina and Jamie began to feel more and more depressed. Tina told her father Ed that she and Jamie would visit him for breakfast, but it was just too painful to visit when all her brother's and sister's children were there with him.

In January of the next year, Tina and Jamie came to visit Ed. They seemed to be happier than Ed remembered seeing them in a long time.

"Guess what?" said Tina. "I'm pregnant."

"Did I hear you right?" answered Ed, feeling that the words were too wonderful to be true, that Tina was finally pregnant.

Tina and Jamie believed that the little painting by Andy Lakey had something to do with their success in having a child. Tina did not want to take any chances, however, so she took her painting out of its frame and brought it with her to her ultrasound screening. She carried it in her blouse pocket during the procedure.

"You're going to have a perfect little baby," the doctor said after viewing the screen.

Ed, Jamie and Tina's whole family are all grateful to Andy for providing them with his wonderful painting at the time they really needed it the most. Their child was born the following October. This was exactly a year after they received their Andy Lakey painting.

An Angel for Kira Rose

Donna had always had a strong belief in angels, but when she watched the television special *Angels the Mysterious Messengers with Patty Duke* in 1994, it really struck a chord in her life. Donna was particularly interested in the spiritual journey that led Andy Lakey to pursue his mission of painting two thousand angel paintings by the year 2000.

153

Donna and her husband Jim went to an angel store in San Juan Capistrano, California where Andy's art was sold. They purchased two original angel sketches by the artist.

Due to a childhood illness, Donna was unable to have children. Soon after purchasing Andy Lakey's artwork, she felt she needed to adopt a child to make her and her husband's lives complete. There were thousands of adoption agencies to choose from, but they decided to adopt a child from a former Soviet Bloc country. They chose Bulgaria as the country of origin for their child. Donna felt compelled to choose a girl, and to name her Kira Rose. Donna did not know the origin of the name, but felt it was significant. She later found to her amazement that Kira is a Bulgarian name that means "Care Giver" and that the rose is the national flower of Bulgaria.

To Donna and Jim's surprise, they had an opportunity to adopt a child within just a few days of their request. A photo of a newborn child was faxed to them. There was just one catch. They had to be in Bulgaria by the next weekend to sign their intent to adopt forms. To do this, Donna had to complete a whole list of requirements. She had to get a passport, a police clearance, a medical clearance, a full set of fingerprints and notarized immigration papers.

Donna went over the list at home that evening and felt it was all quite hopeless. No one could ever accomplish all of these

things in just three days. She got her sketch by Andy Lakey down off the wall and started to cry.

In her darkest hour, Donna prayed, "God, please send your angels to help us. We really would love to have this beautiful baby to share our lives."

The next morning, miracles began to occur. Donna discovered she had made a previous doctor's appointment and was able to take care of her medical needs for the trip. A friend of the family with political ties arranged for all of her security clearances. She was also able to book a flight to Bulgaria. When Donna and Jim reached Bulgaria, they went immediately to the orphanage.

They found to their concern that Kira Rose was in the hospital with a double ear infection. The hospital's conditions were frightening, and it was severely understaffed. When they saw Kira Rose she was very sick, but when she saw Donna and Jim she smiled.

Donna and Jim filed all the adoption papers in Bulgaria. Then, they flew back to the United States without their child. They were sad and tired from their ordeal. Donna prayed for Kira Rose, that she would get well and that she would never have to go to that terrible hospital again. Donna visualized "bubbles of love" around her child as she had read about in Andy Lakey's book.

The next morning, Donna's prayer was answered. When she talked to one of her neighbors, she learned that the woman's

niece had adopted a child from Bulgaria. A real miracle about this coincidence was that this woman had used the same adoption agency and the same attorney as Donna. She contacted the woman's niece and they became immediate friends, and to this day share closeness in their lives.

After nearly a year of fighting bureaucracy and government red tape, Donna and Jim got their baby Kira Rose. The doctor's that examined her said she was in amazingly excellent physical and mental condition for an orphan. In fact, she had suffered no loss of mental function and was actually mentally advanced for her age.

Donna and Jim commissioned Andy Lakey to paint an energy painting with Kira Rose's photo. Painting number 1,796 of the original 2,000 angel series now hangs in Kira Rose's bedroom along with one of the original sketches by Andy that Donna and Jim originally bought.

Touched by a Virgin of Guadalupe Angel

One bright April day, Margaret came into our Ventura, California store. Margaret was six months pregnant and was looking for a gift for her new baby. She pondered the store's angel gifts for several minutes then entered the gallery of art by Andy Lakey at the back of the store.

Margaret had never seen the art before, nor had she even heard of the artist, but she immediately felt a strong sense of spiritual power. She was drawn to a particular painting on the wall.

Margaret turned to my wife Francesca, who had just entered the gallery behind her and said, "This painting is very holy. It has something to do with Hispanics or Indians. This painting has to do with a spiritual apparition somewhere in Mexico."

Francesca was struck with surprise, "How did you know about this painting? It was painted with the spiritual energy of the Virgin of Guadalupe, the patron saint of Mexico. Her image converted the Indians throughout Latin America to Christianity. We gave Andy a photo of the Virgin of Guadalupe. He put it under the canvas when he painted this piece for us."

Margaret was amazed at her vision. She then closed her eyes and put her hand on the painting and received a message. She was so shocked by the message that she did not share it until several months later when she returned to our store with her new born baby.

"Francesca, I have to tell you the rest of my story," said Margaret as she entered our store.

"What happened?" asked Francesca.

"When I put my hand over that painting painted with the energy of the Virgin of Guadalupe, I saw something come out of the painting," replied Margaret. "I saw a little boy running around

inside an old Catholic church. I knew this was a message from the Virgin of Guadalupe. The message was that I was going to have a baby boy."

"Why was this message so impressive?" asked Francesca.

Margaret replied, "The message was impressive because all the medical tests I had, shown I was going to have a girl. When I told my doctors I had got a message I was going to have a boy, I was told it was just wishful thinking."

"Look Francesca," Margaret said pointing to her baby stroller. "I had a baby boy, just like the one the Virgin of Guadalupe showed me."

A Gift from the Angels

Several years ago, Andy Lakey was looking for a bookkeeper. He looked in the Yellow pages and found a bookkeeper whose name stuck in his mind: Angela. Since her name meant "angel," Andy thought to himself that it was a sign he should use this person to do his taxes.

Angela and her husband became more than just business associates with Andy Lakey; they became good friends as well. In time, Angela confided to Andy that she and her husband Steve were having trouble conceiving a child. They had tried everything. For the past year and a half they had spent over $140,000 on

fertility treatments. Angela had done everything that science could suggest for one to do to get pregnant. Nothing worked.

She had become obsessed with having a child, and it was taking over her life and making her very sad. Out of desperation, Angela and Steve decided to adopt a child. Angela told Andy of their plans and he gave her and Steve a six by eight inch painting named "Love Angel."

To Angela and Steve's amazement, they were able to adopt a newborn baby girl within three months of receiving the painting. They named this baby Annalina.

In October of the following year, Angela and Steve purchased a twenty-one by twenty-seven inch painting from Andy. This was one of the original 2,000 angel series Andy was told by a higher power to create.

Less than one year later, a miracle happened to Angela. At the age of forty, with no fertility treatments for over a year, she found out that she was pregnant with her first child. In August of the next year, Angela and Steve's son, Vincente, was born. They feel that Vincente is their gift from the angels.

Angela feels that Andy Lakey's art and his angels continue to touch her life. She is grateful to God and the angels that Andy continues to paint and brings all their miracles to her life.

CHAPTER EIGHT

Messages from the Other Side

Angelic messages continue to come to those who come into contact with the art of Andy Lakey. These messages often bring those who receive them peace, hope and increased spirituality. The following stories further show the significance of this phenomenon on the lives of those who receive these messages.

Mona's Healing Angel

Mona and Anthony always loved Andy Lakey's angel art. They came to our gallery and spent over an hour with us every time they visited. They loved to hear the stories I told of the miracles that happened at our store. Nobody knew of the tragedy that awaited them, and that Mona's story would one day be part of a miracle story I would tell about Andy's art.

On Saturday, February 14th, 2004, Mona's fiancé Anthony came into our store. Anthony looked very sad and seemed like he was in a state of shock. He said that he wanted to visit our gallery of Andy Lakey paintings. When Anthony walked into the gallery,

he asked if he could watch the videos we had about the art and the miracles attributed to it. I started the DVD player; it was set to play five different shows one after another.

After about half an hour later, I went into the gallery and greeted Anthony. I asked if he was okay.

He said, "This is making me feel better. I really thank you for letting me watch these videos."

I asked Anthony what was bothering him. Then Anthony told me the tragic story of his fiancée Mona. Mona was a successful manager of a supermarket in Santa Barbara, California, about half an hour north of my store. Five months earlier, a labor dispute over healthcare benefits had led to an ongoing strike that continued with no relief in sight.

As a result of being out of work for so many months, Mona had her car repossessed and was evicted from her apartment. Mona's fiancé, Anthony, was having financial problems of his own and was living in his office. He could not even help Mona with her housing and transportation dilemmas. As an added humiliation, at age forty-three, Mona now had to return to her hometown of Santa Paula, California, about twenty minutes south east of Ventura, and live with her mother.

On the evening of Friday the 13th of February, while visiting her sister's home in Santa Paula, Mona took the ultimate act of despair. Mona's great niece, Cassandra, found her hanging

lifelessly in a bedroom the next morning. Mona's mother took her to the emergency room at Ventura County Medical Center.

Anthony said that Mona was now in the hospital's intensive care unit. The prognosis was not good. The doctors said that due to the lack of blood to her brain, she was now brain dead. Anthony was still in denial about the fate of his beloved fiancé. He tried to be positive, but deep down inside I personally believed that there was no hope for Mona.

As Anthony and I spoke in the gallery at the back of the store, I noticed that the postman had come by and given my wife, in the front of the store, a "Priority Mail" envelope. Francesca looked puzzled and shook her head when she opened the letter. I figured that it was from someone requesting a refund.

Anthony then told me he wanted to spend some time alone with the art, so I left him and went to talk with Francesca. I told her about Mona, and the tragedy of her suicide attempt.

As I did this, Francesca froze and said, "Oh my God! That is what the letter is about."

"What letter?" I asked.

Francesca brought out the "Priority Envelope" and handed it to me. In it was a hand painted two by four inch original art brooch by Andy Lakey. With the brooch was a letter. I pulled the letter out of the envelope and read it. To my amazement, the letter said, "To Whom This May Concern, I am returning this angel to

you and would like you to donate it to someone/group that cannot afford it and could use the power it may have. Thank you."

The letter had no name on it. We saw the return address on the envelope and found it was from Reno, Nevada. We could not find a record of sending a brooch like this to anyone from Reno. And no one, in the nine years we had been selling Andy Lakey's art, had ever returned a hand painted brooch to us. Francesca and I knew what we were supposed to do with the brooch. We believed it was sent for Anthony, so he could bring it to Mona in the hospital. At least, that's what we thought at the time.

Mona died Monday, February 16th. Her friends Dena and Anthony called us. They both said they had wanted for me to be the reverend for the service of her funeral. They also told me that they planned to bury Mona wearing the brooch by Andy Lakey.

On the afternoon of Wednesday, February 18th, Mona's best friend Dena came to my store. She said that she and Mona's fiancé Anthony had talked and decided that they wanted me to give the presentation at her "viewing" at the mortuary on Friday, February 20th at 7:00 p.m. and at Mona's funeral at 10:00 a.m. the next morning.

I am an ordained minister in the Church of Religious Science, and I run my ministry out of my store. I had only done weddings and an occasional baptism, but I had never presided over a "viewing" or a funeral. I felt both honored and concerned by the

request. I reluctantly agreed to go ahead with this very sad and difficult ordeal.

I spent the next two days putting my notes together for the two sad events that I had agreed to preside over. As I worked on this, it seemed that everything that could stop me from completing my task came at me. My wife Francesca, who runs our store with me, got a bad cold and could not work. My store was overrun with customers, my website was filled with orders and our Japanese partners needed information from me immediately.

In the midst of this confusion, I was hit with a revelation. The angel brooch was not sent for Mona. It was sent for the group and me. It was a sign of healing sent by God.

I arrived at the funeral home in Santa Paula about fifteen minutes early. I first walked over to see Mona's lifeless body in her coffin. Next to her, on her pillow, was the angel brooch by Andy Lakey. The crowd of over one hundred people attending the funeral was lost in grief. They cried and screamed in pain. A death of a loved one by accident or illness was one thing, but a suicide was something different. It was something that all felt was very terrible.

Many Christian groups believe that suicide is a mortal sin. They feel that if a person commits suicide they will not go to heaven. It was my job to preside over this very difficult situation. I had to let these people know what I knew - that a loving God

would not send someone who had lost hope to hell. I knew in my heart that Mona's spirit was alive and that everything was going to be all right.

I walked up to the podium in the funeral home's auditorium. I looked over at Mona's lifeless body lying to my right hand side, waited for the wailing and crying of the audience to subside, and began to speak.

In my presentation, I told the story of the angel brooch and how it came to our store just as Mona's fiancé Anthony told me about Mona's fate. I was not sure if anyone was listening to me at all. I could not get a feel of the crowd's reaction to what I was saying. There was only moaning and crying.

At the end of my presentation, I said, "I am here tonight to let everyone know that this angel brooch was not sent just for Mona. It was sent to heal us all as a group. It came to us as a message that God, angels and miracles do exist and that Mona is going to be okay in heaven."

After my presentation, I left the podium and went into the crowd of Mona's family and friends to try to console them. I soon found this task to be impossible. Everyone was so caught up in the grief of the moment and the need to console one another that my efforts went virtually ignored. I tried to talk to Mona's son, to her mother, as well as to Anthony and Dena, but no one really had much to say to me or really wanted my condolences.

I arrived at the cemetery a half hour early the next morning to preside over the graveside service. It had started to rain and the scene reminded me of the type of classic funeral one would typically find in a Hollywood movie. There was a canopy and some chairs for the immediate family. The rest of the mourners stood in the rain holding black umbrellas.

As we were setting up for the funeral, Dena and Anthony came up to me. They had a look of concern on their faces.

"We have something to tell you," said Anthony. "We've changed our minds about burying Andy Lakey's angel brooch with Mona."

Dena nodded in agreement.

"What are you going to do with it?" I asked.

"We feel that after hearing your service last night, that this broach was sent to heal us as a group, not to heal Mona. Mona's already on the other side and she's okay. We are the ones that really need the healing now," said Anthony. "We want you to give the brooch to Mona's great niece Cassandra, who found Mona after she committed suicide."

I agreed that this was a wonderful idea.

The theme of my service was my personal experience in dealing with Mona's death. Mona and Anthony had asked me to preside over their marriage in front of the cross on the hilltop overlooking the San Buenaventura Mission in Ventura. I expressed

that I would have much rather done that, than performing the service I was instead doing.

I went on to say that marriages are happy, festive occasions. They are filled with laughter, hope and joy. Funerals are sad occasions. They are filled with crying and sad goodbyes, but they also fulfill our belief in God and heaven. These, I said, were the lessons I had to learn and that we all have to learn. Life and death are all part of the same path, and we should find meaning in all these lessons and all the other lessons we receive from God.

In the middle of my sermon, I presented Andy Lakey's angel brooch to Cassandra. As I did this, hush came over the audience and I felt a heavy weight lifted off of everyone's souls, including my own. What had happened to Mona was between her and God and it was not any of our faults. It would take some time, but healing would come to all of us. And the little angel brooch by Andy Lakey had helped me and all the other people at the funeral find our paths to healing.

A Doubting Thomas

One summer's afternoon, two Hispanic women entered our store. One of them, a short woman with dark brown eyes and hair tied in a bun, came over to me, looked me in the eye and asked, "Are you Keith Richardson?"

"Yes, I am," I replied.

The woman looked at me, smiled and said, "Well I slept with you last night."

"You did?" I answered in surprise, and added jokingly, "I really don't think I know you."

The woman laughed and said, "Last night I read your book. When I woke up this morning, your book was laying right beside me. That's how I slept with you."

"Oh!" I said in mock relief. "So, that's how you know me."

The woman introduced herself as Connie, and her friend as Mercedes. They were both originally from the country of Colombia in South America. Connie said Mercedes had loaned her my book. She thought it might help her.

Connie said, "Your book is intriguing, but I am a 'doubting Thomas' and I'm very skeptical of books like yours. I really don't believe in God, angels or anything to do with religion, or spirituality."

I shook my head and said, "That's too bad. But it's your path and you have to walk it and you have to learn your lessons for yourself."

Connie smiled politely and nodded her head and said, "I want to see the Andy Lakey art gallery you talk about in your book."

Being more fluent in Spanish than myself, my wife volunteered to escort the two Hispanic women into the gallery. On

entering, Francesca said in Spanish, "Would you like a real treat? If it's okay with you, I'd like to show you something really interesting. I'd like to show you how the paintings look in the dark."

Both women agreed enthusiastically to find out what she was talking about. Francesca slowly dimmed the gallery lights until the room was very dimly lit. She kept the lights down for a moment then turned them on again. Francesca noticed that Connie appeared to be deeply moved was crying.

"What did you see?" Francesca asked Connie.

"I saw the Virgin of Guadalupe and she was crying," Connie replied.

"What does that mean to you?" asked Francesca.

Connie took several deep breaths and answered, "Two years ago, my baby brother was diagnosed with something very embarrassing and terrible," she sobbed. "I was devastated. I didn't know where to turn to for help. A Mexican friend of mine suggested that I make a special prayer to the Virgin of Guadalupe. This is not a belief we share in Colombia, but I felt it was worth a try. I told the Virgin to take care of my brother. Less than two months after my prayer, my brother was killed in a terrible car accident. I was angry with the Virgin of Guadalupe. I told her I didn't believe in her. She didn't listen to my prayer."

"That's too bad," replied Francesca. "Most people we speak to say the Virgin of Guadalupe has helped them."

"A few months ago," Connie continued, "someone gave me a small picture of the Virgin of Guadalupe. I didn't want it and I didn't like it, but I put it on the wall anyway. Yesterday, I was cleaning my house and saw the picture on the wall. It upset me so much I put it in the drawer. Today, I came to your store at the insistence of my friend Mercedes. I admit I was negative and very skeptical. Seeing the Virgin of Guadalupe in the room crying has made me finally understand something. If my brother hadn't been killed in that car accident, he would have died a slow agonizing death. My prayer to the Virgin was answered, I just didn't understand. I now know there is a God and there are angels. I also know that the stories in your husband's book are real."

A Message from the Pyramid

One spring day, Debbie, a major collector of Andy Lakey's art, visited us from Ohio. We took her to Andy's studio, which was then located in Santa Barbara. Andy had some personal business come up and asked me to entertain Debbie for the day. I believe there are no coincidences. Debbie and I were brought together because we had a lot in common. We were brought together so she could tell me her many stories about Andy's art. The following story is one of the more unusual ones that she had told me.

In the fall of 1995, Andy Lakey led a tour group to Egypt. Debbie, learning of this opportunity to visit Egypt and meet Andy, purchased a ticket for the tour. The most impressive thing Debbie saw in Egypt was the Great Pyramid of Giza. When the opportunity came up to spend the night in the King's Chamber of the pyramid with Andy and ten other tour members, Debbie jumped at the chance.

Andy Lakey had received permission from the Egyptian government for the stay in the pyramid. He planned to sketch over 2,000 angel pictures on Egyptian papyrus paper while in the King's Chamber.

The group started their ascent into the pyramid about mid-afternoon. The inside of the pyramid was damp and stuffy. The group members climbed up stone steps, through dark mazes and swung across rope ladders. They finally ascended into the dimly lit King's Chamber.

Debbie lay down, exhausted, on a cold stone slab and watched as Andy unloaded his backpack filled with thousands of little papyrus papers and started to sketch angels. Debbie was about to doze off when she felt something move beneath her. It was a strange sensation. She said that it felt like an icy hand reaching through the stone slab and running from the base of her spine to the top of her head.

Debbie screamed, "My God, something just touched me."

Andy and the others in the chamber were shaken by Debbie's screams. There was no one near enough to Debbie to touch her. So, they all tried to calm her down.

"Maybe it was a rat," said Andy.

Debbie shook her head and said, "It didn't feel like a rat. It felt like a hand. I think I would have known if a rat was lying under me."

The group in the chamber discussed Debbie's experience for some time that evening. No one could say for sure what Debbie had felt. All they knew was that Debbie was certain she had felt something.

The next day Debbie told an Egyptologists about her experience. He said, "I can't understand why you would feel something like that in such a deep chamber of the pyramid. It was probably just your imagination. Rats and other animals just don't go that far into the pyramid."

Debbie had thought about her experience in the pyramid over the next few years. She told me that she now believes that she was given a message from the other side while in the King's Chamber. After Debbie read my book, she realized that her experience was really not that unusual at all. It was a psychomanteum experience. And why wouldn't she have one? She had been in the world's largest Psychomanteum - The Great Pyramid of Giza.

The Golden Ray

Geneva, a psychic from Colorado told me this story a few years ago. She said that she had a painting by Andy Lakey, which was very rare for someone in Colorado since there are no galleries with Andy's art in the state. She told me the following story of how she got her piece of art.

Geneva was on vacation in La Jolla, California when she felt compelled to enter an art gallery in the downtown area that featured the art of Andy Lakey. She said she had no intention of purchasing anything. She thought the art was too expensive and that it would be too much trouble to take it all the way back with her to Colorado.

As Geneva walked through the gallery, something unusual caught her eye. Coming from the center of one of Andy Lakey's artworks shined a golden ray of light. It came across the gallery and the beam engulfed Geneva's whole body. She saw this as a sign from God. She had to purchase this piece of art and bring it back with her to Colorado.

Geneva purchased the piece of art, took it home and then placed it on a tripod. She is a second-generation psychic and keeps the tripod on the table she does readings on. All of her clients tell her that they see colors coming out of her painting by Lakey. Geneva is still impressed by the golden rays of light that it

continues to bring to her. She sees this as God's love shining through from the other side.

Michelle's Portrait

One morning, I received a call from a man from Sacramento, California, which is located about seven hours north of Ventura. The man told me that he and his family members had read my book, and they felt compelled to visit our store. The family arrived around noon on a Saturday. There were six people in total. I began to give them a tour of our store, feeling honored that they would come so far just to see us.

As I spoke to the family members, I noticed their reactions and could tell there was something seriously wrong. A slightly built woman in her early forties opened her wallet and took out a small pile of photos of a young woman.

The woman looked at me sadly and said, "Her name is Michelle."

The photo showed a strikingly radiant eighteen-year-old woman. She had long dark hair and bright brown eyes. She shined with beauty and life. I see this type of thing all the time, however, and could tell by the reaction of the members of the group that something terrible had happened to Michelle.

"She died didn't she?" I asked.

I saw the eyes of the members of the group well up with tears as they all nodded. "Yes!" several members of the group said in unison.

"What did she die of?" I asked.

An older man, who introduced himself as Michelle's grandfather, stepped forward and said, "Michelle was murdered. She was working as an aide at a high school in Sacramento when she was raped and brutally killed by a newly hired school janitor. Her murder has received national coverage. It's led to the legislation of a new state law called 'Michelle's Law.' The new law makes school officials complete fingerprint screening and full authorization from law enforcement officials before new employees can be hired." Michelle's grandfather continued, "Ever since her murder, we've been getting messages from her. My wife over there got a message from Michelle the other day. She told me Michelle said she'd opened a 'Pandora's Box.' She says she was sacrificed to bring about change and end corruption in the school system. You know she really has. They not only found really bad hiring practices at that school, but they also found many other things going on including much corruption and misappropriation of funds. They're firing many of the school officials in our district, from the superintendent on down."

Michelle's grandfather turned to me and looked a little embarrassed. Then he shook his head and said, "You know, I got a

message in a dream last week from Michelle after I read your book. She told me to come to your store here in Ventura. She said she was going to communicate with my family and me here. I told the other members of my family about my dream. They said we had to visit your store. I called you and told you about our plans. Then we took time off work, packed up our suitcases and headed for Ventura."

My wife Francesca and our employee Jane led the family into the gallery of angel paintings by Andy Lakey. They took six medium sized paintings off the walls and put them on the laps of the six family members. Francesca had them close their eyes and pray to God about Michelle. Everyone began to cry.

Michelle's grandmother said, "I heard Michelle speak. She said she was okay."

Everyone else in the room agreed they felt a definite sense of peace and warmth. They immediately felt Michelle's presence in the gallery. They knew they had come for a reason. Michelle wanted them to overcome their grief.

As they were leaving, the family members shared their photos of Michelle with Francesca, Jane and me. As I looked at the photos, I saw something unusual in one of them. In the backdrop of a photo studio portrait were objects that appeared to be the angelic figures that Andy Lakey paints. This was not just a fuzzy image, or a crack in the wall, but a clear representation of Andy's angels.

"Did you see these figures in your photo?" I asked.

The grandfather replied, "This photo was taken just a few months before Michelle's murder. We'd never even heard of Andy Lakey back then. After Michelle's death, we went to an angel store in Sacramento. There we learned about Andy Lakey and his spiritual art. We met Andy when he made a public appearance at that store in December and gave him this photo so he could do a spiritual energy painting with it. We didn't even notice the angels in the background until Andy brought them to our attention."

"Were Andy's angels on a backdrop they had at the photo studio?" I asked.

"No," Michelle's grandfather replied, "I took the photo to the studio when we got it back from Andy Lakey. They told me they only used black curtains as backdrops. They couldn't explain the figures in the background of Michelle's portrait either. Our family now believes that this was a sign to us from the other side to help us deal with our grief from Michelle's murder."

Michelle's grandfather stopped for a moment to wipe the tears from his eyes, and then said, "We all know there have always been angels around Michelle and there'll always be angels around her. She's in a safe place, where she'll never be hurt again, but we can't help missing her."

Who's Eddie?

One summer's afternoon, a young Hispanic couple and their eighteen-month-old baby came into our art gallery. I showed the couple the artwork by Andy Lakey. They were very impressed by the sensation of heat and tingling they got when they put their hands over the art.

As they were doing this, the husband looked at me skeptically and said, "Do we really feel this, or are you just giving us some kind of psychological cue to make us think we feel something?"

The man's remark caught me off guard. I thought for a second and said, "Why don't you let your baby put his hands over the painting and see if he feels something. I don't think I can give a baby a psychological cue."

"Okay," the man replied, "let's try it."

The man picked up the baby, lifted him to the painting, grasped his hand and put it just above the painted angel. As the man did this, a strange look came over the baby's face and he gently said the word, "Eddie."

After the baby said this, I notice that the man and his wife looked visibly shaken. The man again put the baby's hand over the painting and the baby shouted it out this time, "Eddieee!"

With this, the couple began to weep openly. They put the child on the floor and hugged each other. This whole incident had

made me ill at ease. I felt like an outsider in some sort of personal family problem. I waited until the couple had calmed down and then I asked, "Who's Eddie?"

The man looked at me sadly and said, "Eddie was my cousin. He died before our baby was born. We've never even talked about him in front of our baby. Why do you think he'd call his name? Has anything like this ever happened here before?"

"Things like this happen here all the time, but I don't know why," I replied.

The White Lady

One day, I received a call from a customer named Joe, he was from New Jersey. He told me, "Keith, I've got a story for you. You have to put it in your book."

"What is it Joe?" I asked.

"Well," he replied, "do you remember a few months ago when I bought a dozen miniature paintings by Andy Lakey from you?"

"Yes," I answered.

Joe continued, "I gave one of those little paintings to a four-year-old girl from North Carolina named Lori. Lori had cancer of the brain. Her doctors said she had only a few months to live. I thought the painting would give Lori and her family some comfort. Lori loved her little painting. She took it everywhere with

her. Within a day or two of receiving it, something strange began to happen. Lori began telling her parents and her aunt who cared for her about her visits from a beautiful lady dressed all in white.

"Lori said the lady would tell her to come with her. Whenever the lady came to her, Lori would protest saying, 'I can't go with you, I don't want to leave my daddy.' When Lori told this story to her father, he cried. He loved Lori so much, but he knew she was in the final stages of her cancer and was suffering terribly. He knew her life was coming to an end.

"Her father said, 'Lori it's all right to go with the white lady. Go with her the next time that she calls you.' The next day, while Lori's father was at work, she saw the white lady again. Lori's aunt was with her, the white lady again beckoned Lori to come with her. She told her aunt about this and said, 'I can't go, I don't want to leave my daddy.' Her aunt reassured her saying, 'It's okay Lori, your daddy told me it's all right, and you can go with her.' Lori breathed her last breath, then died in her aunt's arms with a smile on her face."

Joe added that the doctors and morticians that saw Lori's face were astonished. They said that a smile like hers could not be recreated, that it had to be real. Lori had died in peace. Her suffering was over. Lori's parents believe the white lady she had spoken of had finally led her to heaven.

I'm not Supposed to Sell this Painting

On a Friday afternoon in March, I got a call from Andy Lakey. He informed me, "Keith, I just heard the most mind-blowing story. You've got to put it in your next book. There's a Mr. McNamara in Fallbrook, California who has a painting that won't let him sell it. You've got to call him and get this story."

As I spoke to Andy, I remembered something that really concerned me. I was supposed to be in Temecula, about three hours south of our store, in about an hour. I don't know how I could have forgotten such an important commitment, but I did.

I told Andy I had to go, and I rushed out of my store to my car and made a new land speed record from Ventura to Temecula. There was a message waiting for me at the store's counter. It was from Mr. McNamara, so I called him back. He told me Fallbrook was only ten miles from Temecula and he said he could meet me at the bookstore in about half-an-hour.

When Mr. McNamara arrived, he seemed to know who I was right away, and came up and introduced himself. "I've never had anything like this happen before. I just kept rationalizing all the coincidences in my life. But now I just can't rationalize them anymore."

"What happened to you?" I asked.

Mr. McNamara looked at me, put his hands over his eyes and shook his head. Then he looked at me and said, "It all started

in 1994 when I bought a painting by Andy Lakey at a local furniture store. It was a sixteen by twenty-inch painting with a beautiful golden angel on it. The number on the painting was 808. I don't know why I bought it. It just seemed to have called me. Does that make sense to you?"

I nodded and answered, "I've heard of things like this happening before."

Mr. McNamara continued, "Well I took the painting home, and a few days later, as I was looking at it, I got this strange inspiration. I was supposed to write a book. This didn't make much sense to me. I have only an eighth grade education. I spent much of my life in the military and I'd never written anything substantial in my life."

Mr. McNamara went on to tell me that he writes romantic novels under the pen name Sterling Webster. He is now completing his fourth novel and each has brought him more wealth and success.

Mr. McNamara then explained that he and his wife had recently decided to move from California to Wisconsin. They looked all over the state for a perfect place to move, but just couldn't find what they were looking for. Before leaving for his second trip, McNamara rubbed the angel on his painting and said a prayer about his wish to find a new home in Wisconsin.

When he got to Wisconsin, he had little hope of finding the property he was looking for, but then a miracle happened. He accidentally found a piece of property he loved, property that was not supposed to be for sale. After some discussion with the owner, however, he acquired the property, and on March 8, 1998 he put his own house on the market.

The real estate market in that part of California was really depressed at the time. McNamara was concerned that it might take months or even years to sell his home in Fallbrook. The realtors advised him not to be optimistic. McNamara felt a little depressed about his prospects for selling his home. He sat down next to his angel painting and said, "Please help us find a buyer for our home."

Within four days, McNamara had two bids from two qualified buyers for his home. He took the best offer and sold it that day. "But that's not the end of my story," said McNamara. "It got much stranger after we sold the house."

I looked out the window of the bookstore at this point in Mr. McNamara's story. I noticed that the clouds in the sky had turned a deep shade of black. The news I had heard on my car radio all the way down to Temecula had reported sunny weather and no chance of rain. But, seeing these clouds, I knew a major storm front was about to hit us.

I interrupted McNamara, and said, "It looks like something really bad is coming down on us doesn't it?"

He looked out the window and nodded yes. Then McNamara continued his story, "When we'd sold our home, my wife and I decided to sell a few of our belongings so we wouldn't have to move so much stuff to Wisconsin. I thought one of the things we could sell would be our angel painting by Andy Lakey. I did some research and found what I believed to be a fair price for my painting."

"I contacted Andy Lakey's art dealer in Carlsbad, California. He was most anxious to purchase my painting at that price. We set the date of March 23 to get together and complete our transaction. Our original meeting was set for 10:00 a.m. The dealer later moved this up to 12:30 p.m."

"I got up early that morning and prepared for my one hour trip to Carlsbad. I went over to the wall where my angel painting hung, and tried to get it off the wall. To my frustration, I found I couldn't get the painting off the wall. It just wouldn't come off the hook. I finally got a screwdriver and pried and turned my painting around for it to come off my wall. Once I finally got the painting down, I put it in my truck and prepared to get on my way."

At this point in McNamara's story, a loud clap of thunder rocked the bookstore. The glass in the store's windows rattled and

the lights flashed off then on again. Great quantities of hail fell from the sky, blanketing the parking lot in front of us.

McNamara looked at me, shook his head, and said, "This is just how the weather was when I left home to sell my painting." He then continued his story, "I had trouble from the beginning. At first my brand new Ford truck wouldn't start. After about five minutes, I got it going. It drove down my driveway to my electric gate. To my astonishment, the gate wouldn't open. I had to get out in the rain and manually crank the gate open. I got back into the truck and the engine died again. I drove out of my drive and the electric gate wouldn't close. So I got out of my truck, manually closed the gate and had to climb over the fence.

"My truck continued to run terribly. It had never run this way before. It stalled every few miles and I had to get it going again. As I felt things couldn't get any worse, they did. I heard a thump, thump, thump coming from the front of my truck. My left front tire was flat. I got out into the pouring rain and realized something terrible. My new truck's spare tire was also flat.

"I walked off the freeway off-ramp to a gas station. I was soaking wet by this time. The station mechanic brought a tow truck to my car and checked my tire. To my amazement, the mechanic couldn't find anything wrong with my tire. There was no tear, no nail, and no hole at all. He filled it with air and it worked perfectly.

186

"I thought my problems were over when I reached the freeway off-ramp to Carlsbad. I was wrong. To my dismay, all the traffic lights in town were broken. They were all red. Police had to direct all the traffic and I was snarled in a terrible traffic jam. My truck continued to stall as I slowly moved toward the store where I was to sell my angel painting.

"When I finally got to the store, I found there was nowhere to park. I circled the block several times and finally found a parking space about half-a-mile away. I got out in the still pouring rain, put the painting under my jacket, and walked to the store

"By the time I got to the store, I was soaked head to toe. The dealer's wife greeted me and told me he was unexpectedly called into a meeting across town and wouldn't be able to see me for about half-an-hour. I waited forty-five minutes and the dealer didn't show up. His wife paged him and he didn't return her call.

"At this point, I heard a voice inside my head say to me, 'Pick up your angel painting and go home.' I apologized to the dealer's wife and said I had to go. I picked up my painting, and just three steps out of the door it stopped raining and the sun came out.

"I got back to my truck. It started up and ran fine. All the stoplights in Carlsbad even worked. I then headed for the Ford dealer where I had bought my truck. They did a thorough computer analysis of every system in my vehicle. They could find absolutely nothing wrong with it at all. I then drove home. My electric gate

worked perfectly. In fact, nothing has gone wrong in my life since I put my angel painting by Andy Lakey back on my wall.

"I later called the art dealer in Carlsbad and told him that due to new circumstances in my life, I'm not going to be selling my angel painting."

Mr. McNamara assures me he never ever plans to sell this painting. He knows that God's angels have made it clear that this painting is supposed to stay with him.

The Three Wishes

For the past two and a half years, Mary Ellen, the director of a Roman Catholic organization in Clinton, Iowa, had been waging a fight against her Bishop's $29 million "mega-church" and school project for the town of Clinton. This project was said to be necessary due to the shortage of Catholic priests. One outcome of this project, though, would be the closing and demolishing of five historic Catholic churches.

Mary Ellen had been the leader of the opposition to this project. She worked to organize historic and spiritual groups in and out of the parish to fight the Bishop's proposal. Neither her parish priest nor her Bishop would listen to her group's concerns about neither the destruction of the historic churches nor the excessive cost of the proposed project.

The ongoing fight over this project led to a split in the Church. Many once fervent Catholics left the parish. The parish priest forced the project through with a handful of younger parishioners. This action shocked Catholics throughout the state of Iowa and even offended the Protestants in the town of Clinton.

Mary Ellen spent many hours working with Iowa's historical society in Des Moines. Her goal was to get the endangered parishes on the National register of Historic Places. This way, if all else failed, she could still save the parishes through the legal system.

The struggle with Church officials dragged on for over two years. Mary Ellen thought her side was making little or no progress in their fight. They ran publicity campaigns and wrote newsletters, but the Church did not back down.

In April of 1998, Mary Ellen received a letter from her friend Dorothy from Lindsborg, Kansas. The letter described the spiritual power of the art of Andy Lakey. Mary Ellen became excited at the prospect of this spiritual art and called Dorothy.

"Are these paintings some sort of 'new age' thing?" asked Mary Ellen.

"No," replied Dorothy, "the Pope has one in the Vatican."

"Do you think one of Andy Lakey's paintings could help us win our church fight?" Mary Ellen asked.

Dorothy answered, "My own experience with his art has shown me these paintings are very powerful. They have what I call 'angel power.' I'm certain his art will help you."

That night, Mary Ellen says the spirit of Father Frederick Cyrille Jean, the French pioneer and missionary, visited her. Father Jean had established the Catholic Church in Iowa in the 19th Century. Father Jean urged Mary Ellen to get a painting by Andy Lakey, saying that the painting would be the key to solving the problems with the diocese.

When she awoke the next morning, Mary Ellen again called her friend Dorothy in Kansas, and asked her, "Where do I get an Andy Lakey painting?"

"My friend Debora has a store in Lindsborg that sells Andy Lakey's art," Dorothy replied.

Dorothy gave her friend Debora's number. Mary Ellen then called Debora at her store and said, "Debora, I need a painting by Andy Lakey. I just have one problem. I don't have any money to buy one."

"We could set you up on a lay-away plan," Debora responded.

"How soon can I get my angel painting?" asked Mary Ellen. "I won't be coming to Kansas until the fall, and I can't make any payments for at least a month."

Things seemed pretty hopeless for Mary Ellen. It seemed like God did not want her to have one of Andy Lakey's angel paintings. Then, the miracles began to happen. Two days later, she got an unrequested new credit card in the mail. Mary Ellen believes an angel sent it to her. She again called her friend Dorothy.

"Dorothy, a miracle has happened. I now know I'm supposed to have a painting by Andy Lakey," said Mary Ellen. "Please pick out the most powerful and spiritual painting you can for me."

Dorothy did as Mary Ellen instructed. She gave Mary Ellen's credit card number to Debora and purchased a miniature painting by Andy Lakey.

The last week in April 1998, Mary Ellen received her painting. At first she was disappointed with what she saw. It was only three by three and a half inches. This was all she could afford, even with the credit card. She felt it was so tiny and plain, and had trouble believing that something that appeared to be an insignificant little painting could solve her large church problem.

Mary Ellen took the little painting upstairs to her bedroom and sprinkled it with holy water before hanging it in her bedroom. That night she felt the energy in her whole house change. She felt a sense of peace come over herself. She felt energy coming from her

painting, like a small force field. Mary Ellen decided to name the angel on the painting "Marium."

Mary Ellen lay down on her bed and meditated upon her new little painting. As she did this, she said a prayer, "God, please help us win our church fight and make this happen soon."

Forty-eight hours later, Mary Ellen got a phone call from a friend and fellow fighter for her cause. Her friend informed her that there was a cryptic announcement in the diocesan newspaper that the plan for the "mega-church" in Clinton, Iowa had been turned down.

Mary Ellen knew that she had won, and that her historic churches had been saved from demolition. She looked up at her little angel painting and believed that the power of her prayer made the officials at the diocesan office admit that her group had won the fight and put this in print.

Mary Ellen now knew what her next prayer had to be. She needed help with all the bills she had accumulated due to the fight against the Church. She made her second prayer with the little painting, "God, please help me get the money I need to pay my bills."

Within two days, Mary Ellen received a major donation from a priest she had contacted from a parish north of Clinton. She again thanked God and His angels for their help.

Mary Ellen asked for her third favor from God and His angels when she got a rejection letter from the Historical Society of Iowa. This letter refused the nomination of the Father Jean House, in which she lived, as a historical site. The letter explained that the refusal was because the story of the house's history was too complicated and confusing. The house had been used for too many purposes over the years to give it any specific historical significance.

Mary Ellen called the state historical office and asked, "Is there any chance of a reprieve in the appeals process for Father Jean House?"

The official replied, "Yes there is, but it'll be really difficult."

Later, Mary Ellen put her little angel painting on her lap and prayed, "I want this house on the register of historic places. After all we've been through in the church fight, this just has to happen."

The next morning, Mary Ellen spoke to a second state official. He had good news. In a recent search for the historical significance of Father Jean House, they had found a microfilm with an old map on it from the year 1886. The map showed the house and had vital information that would assure the house's preservation as a state historical site.

Mary Ellen does not think the church fight would have gone in her favor so quickly without the painting. She says, "I had to make the sacrifice... There is a price one has to pay for winning. And for me it was the price of my angel."

Angel Sketch Number 214

One day in late July, John and his wife Mary, from Scottsdale, Arizona, came to our store. They wanted to see our angel sketches by Andy Lakey. John told me he liked the sketches better than Lakey's paintings. He felt they captured the essence of his artistic ability.

On showing John and Mary the six sketches we had available in our store, John looked at me disappointedly and said, "I can't believe you went through all the sketches you had back when we were in your store last year. I know you told us we should buy our sketch then. You said they would sell out really quickly. You had over one hundred sketches." John added, "When you told us that, it really turned us off. We thought you were high-pressuring us. Now we see you were right, there's hardly anything left at all."

I said, "John, this is the last of this series of sketches Lakey's ever going to make. These are the last six sketches available anywhere that I know of."

John looked at Mary and told her, "I have to have more of this sketch series. We have two already but we need more."

Mary was not as enthusiastic about the quest for sketches. She went into another part of our store and looked at angel gift items. John took every sketch down from the wall of the gallery and laid them on the floor side by side. Then he walked back and forth and studied them intensely. John narrowed his choice down to three, and then to two. He called Mary to see what she thought.

Mary shook her head and made a scowling look at John then she said, "We don't need two of these sketches. Where would we put them? We only need one more sketch."

John and Mary stood in the gallery bickering over the sketches for nearly an hour. They finally agreed upon a green angel sketch with a green mat. Both felt it would go well with the other sketches they owned.

I picked up the sketch and noticed that the certificate behind it had the number two hundred and fourteen on it. "Does the number two hundred and fourteen mean anything to both of you?" I asked.

John and Mary looked at each other and shrugged. I thought for a moment and looked at the number on the back of the sketch again. I realized that two-fourteen also translates to February 14th. "Does Valentine's Day have any significance in your lives?" I asked.

John and Mary looked at me startled, their mouths opened and their eyes had a look of shock. "It's, it's our wedding anniversary," said John, shaking his head in astonishment.

"What are the odds of this?" I exclaimed. "There were over one hundred sketches in our store last year. Of those, only six were left. Of these, you picked the one with your anniversary date on it. The sketches really do know who they belong to, don't they?"

John and Mary nodded in agreement. They had waited a year to get their sketch. And their sketch had waited a year for them to purchase it.

A Message for Theresa

One spring afternoon, a tall blonde woman who appeared to be in her early thirties entered our store. She seemed excited with what she saw.

"Oh, wow! It's an angel store," she exclaimed. "I've always wanted to see a store like this. It's really beautiful." She walked over to my wife Francesca and said, "I plan to write a book about angels. I want to call it *In the Company of Angels*."

"My husband Keith knows a lot about writing and publishing books, let me get him. I know he'd love to help you," Francesca said.

Francesca called me over to talk to the woman. She introduced herself as Theresa. We talked about writing and I gave

her some hints on getting her book published. I also told her about my book, and how it was touching people's lives throughout the world.

"Exactly what is your book about?" Theresa asked.

"It's kind of complicated and kind of strange," I explained. "Let me show you something, so you can understand what I mean."

I led Theresa to the gallery of Andy Lakey art at the rear of our store. I took a painting off the wall and told her, "Put your hand just above this painting and tell me what you feel."

Theresa looked at me a little skeptically, but complied anyway. "Wow!" she shouted. "I feel something. It's really weird, but I feel heat and tingling coming off this painting."

I opened my book to page thirty-one and showed her that was exactly what I had written down about what I felt the first time I put my hands over one of Lakey's art works.

"Why does it do this?" asked Theresa.

"I don't know," I answered. "It seems to be some sort of message from the other side."

As Theresa held the painting, I noticed that her eyes had welled up with tears.

"Is there something bothering you?" I asked.

Theresa sobbed and nodded her head yes. She put the painting down on the table and rubbed a tear from her eye. "I flew

in from Kentucky yesterday. I took my sister's kids to see their aunt," she whimpered. "It's all a really sad story."

"What happened?" I asked.

"Well," continued Theresa, "two and a half years ago my sister, her husband and her two children were driving home when they were hit head on by another car. My sister's husband was killed instantly in the crash. The kids were just babies. They were in car seats. They weren't hurt badly. My sister was in a coma by the time they got her to the hospital. I was with her at the hospital's intensive care unit. I swear I saw her spirit. I said, 'You can't leave. You have your children. They need you.' My sister's been in a coma for the past two and a half years now. I don't think she's ever going to recover. I have taken care of her children ever since. My husband and I feel they are our children now."

"That's a really sad story," I said. "We hear a lot of stories like yours here. I hope your sister gets better."

We walked to the front of the store and talked a little more.

"You know," said Teresa, "I didn't mean to come to your store. I was headed for the Mission San Buenaventura. The only place I could find to park was in front of your store."

"That happens a lot here," I told her. "Some people think it's synchronicity. They believe they've been guided here for a reason."

"I think I have been guided here for a reason too," said Theresa. "I think I'm supposed to contact my sister."

Theresa returned to the gallery and took a large painting with four angels on it off the wall. She put it on her lap and sat on the bench in the gallery. I dimmed the lights, told her to pray, and then I left the room.

About ten minutes later, I noticed Theresa putting the painting back on the wall. I walked back into the gallery to see her. Her eyes were red, and her face flushed from crying.

"What did you see?" I asked.

"I saw my sister, she told me to let go of her. I had to go on with my life and she needed to be free to go to the other side. This is something I've known for a long time," said Theresa. "I just needed to be shown, so I could truly understand what I needed to do."

The Vision

Juanita, a striking woman of African American and Hispanic decent, works as a lay minister at the Full Gospel Church out of Oxnard, California. After several months of coming to our store and experiencing Andy Lakey's art, she commissioned a painting with seven golden angels on it. Juanita shared her painting with her friends and the members of their congregation. Everyone loved it. Juanita felt blessed to have such an anointed piece of art

in her life. This piece of art helped Juanita understand the meaning and purpose of God's angels.

In the fall of 1998, Juanita's husband, Bill, began to feel very ill. On visiting his doctor, Bill received terrible news. He had terminal cancer. Bill and Juanita began making weekly trips to UCLA Medical Center in West Los Angeles, over an hour drive from their home in Oxnard, California. There, Bill received chemotherapy. Despite all of their efforts, the cancer continued to spread and Bill felt worse and worse.

By the winter of 1998, Juanita was beginning to lose hope. Then she remembered her painting. She took it off the wall, put it on her lap and said a prayer, "God, please send your angels to help Bill. We really need him to continue our spiritual ministry in Christ. Lord, let me know you've heard my prayer. Please send me a sign from heaven. I really need it now more than ever before."

Juanita, Bill and their daughter arrived at UCLA Medical Center about 2:00 p.m. As they entered the waiting room at the cancer ward, Juanita was startled to see two little African-American girls playing on the floor. She nearly stepped on one of them and had to jump back in order to avoid the other girl.

Bill went into the ward for his chemotherapy. Juanita sat down in a chair next to her daughter and began to sketch spiritual drawings on a pad of paper she had brought with her. As Juanita

sketched, one of the little girls who had been playing on the floor of the waiting room walked over to her.

The girl appeared to be about seven years old. She had long braided, black hair and beautiful big brown eyes. "What are you drawing?" she asked.

"I'm drawing my vision," Juanita replied.

"Was that your husband that came in with you?" the little girl asked.

"Yes," said Juanita.

"What's the matter with him?" the little girl asked.

"He has cancer," Juanita said sadly.

"Don't worry about him," said the little girl. "Just believe in *Psalm 91* and everything will be okay."

The little girl then changed the subject and said, "Would you like to see my vision?"

"Sure I would," Juanita replied playfully.

"You can only see my vision if you truly believe," said the little girl. "Do you believe in *Psalm 91*?"

Juanita was dumbstruck by this question. She was not sure how such a small child could know scripture. *Psalm 91* was one of Juanita's favorite verses in the Bible. It reads, "God shall send his angels to watch over you to guide and protect you in all His ways."

Juanita said, "Child, I truly do believe. I believe in the almighty God and all His angels."

With this, the little girl put her hand on Juanita's forehead. Juanita remembers the warmth and sense of peace she felt as the child touched her. Then, she said she felt transported from the hospital ward to the most beautiful place she had ever seen. It was heaven and there were seven elegant golden angels with her. The two little African American girls were there too. Praying to God in the angel's presence, Juanita could hear beautiful music playing and a choir singing.

The next thing Juanita remembers is her daughter nudging her, "Mom wake up!"

"I'm not sleeping," replied Juanita. "I'm seeing a vision."

"No mom. You were sleeping," responded her daughter.

Juanita looked around the room and found that the two little girls were gone. She then proceeded to draw on the pad she had brought with her. She drew the little girl she had seen, and the vision the girl had given her.

The next day, when they returned to UCLA Medical Center, Juanita brought her drawings with her. She wanted to share them with the little girl. Juanita was disappointed when she did not see the girl in the ward.

Juanita walked over to the nursing station and asked the nurse on duty, "Have you seen the little black girl that was here last week when I came here?"

The nurse, a tall slender African American woman in her thirties, looked at Juanita a little puzzled and said, "Ma'am, this is an adult ward. No children are allowed up here."

Juanita persisted, "I know I saw a little girl up here last week. I even had to step over her when I came in." Juanita then showed the nurse the sketch she had done of the girl.

The nurse turned pale and gasped, "I know that little girl. She's really spiritual. She always asked me if I believed in *Psalm 91*. That's the Psalm about angels you know."

Juanita nodded and said, "I know."

"But you couldn't have seen this little girl. She died on my cancer ward last year," replied the nurse.

Juanita's husband Bill passed away from his cancer a little over three months after this experience. Juanita believes that the young girl came to help her understand that heaven is a beautiful place and that it was her husband's time to go to the other side. She needed to accept that fact in order to be able continue her spiritual ministry with her friends and family.

CHAPTER NINE
Saved by an Angel

In recent years, as I have received stories from people throughout the United States and around the world, I have discovered a new type of story about Andy Lakey's art. These stories show how people's lives are not only changed by Andy's art, but people claim that having the art has actually saved their lives.

The following stories go beyond the typical "good luck charm" stories one often hears. They show a genuine spiritual connection between Andy's art and the people's lives they have saved.

Dorothy's Salvation

Dorothy moved to Lindsborg, Kansas in 1993. She felt guided by God to move there. During her first two years, she was very happy in the little cottage she lived in on Main Street. Every day, she would look to the sky and see beautiful angels formed in

the sky. Sometimes Dorothy would see a whole flight of angels in the clouds above her.

For the past three years, Dorothy noticed that the angels stopped appearing in the clouds above Lindsborg. Dorothy felt that maybe they still appeared, but she had become too busy and bogged down with her personal problems to care or notice anymore.

In the summer of 1996, Dorothy's friend Debora came to Lindsborg and opened an angel store. Dorothy was concerned for Debora. She could not understand why she would open such an unusual shop in Lindsborg. It is a small town and the people did not usually support their local shops. Furthermore, tourism, a main stay of the Scandinavian community in Lindsborg, had been down the past several years. Much to Dorothy's surprise and delight, Debora went full steam into her new venture. In a short time, her angel store was one of the most popular businesses in Lindsborg.

One day, while visiting her shop, Debora approached Dorothy excitedly and said, "Dorothy, I can't believe it. It's a miracle of God. I've been able to get Andy Lakey originals in my store."

Dorothy responded, "Who's Andy Lakey? I've never heard of him."

Debora replied, "Andy's the most famous living angel artist. He paints the angels he saw in a near death experience. He's been on many television programs. And his art is in the Vatican."

Debora took Dorothy to see the small original paintings she had in her store. Dorothy looked at them disapprovingly and shook her head. "I really don't like this art very much," she said. "They're too odd looking and I really don't like the colors. They're too weird."

In the fall of 1997, Dorothy began to feel more and more sick. She began to visit doctors and specialists, receiving one medical test after another. They could not find a reason for Dorothy's illness.

One day, as Dorothy was feeling particularly sick, her friend Debora called and invited her to her angel store. Debora had recently decorated the store with plants, comfortable chairs and candles. She had also set up a little nook for quiet talk and meditation.

Debora took Dorothy to the meditation nook and had her sit down. She told Dorothy to hold one of Lakey's miniature paintings in her hands and meditate for a while. Dorothy did as her friend asked and found, to her surprise, that this experience made her feel at peace, bringing her comfort and reducing her pain.

Dorothy began to come to Debora's store on a regular basis. As she did, she became more and more drawn to the art of

Andy Lakey. One particular painting, a star shaped piece with one little angel on it, seemed to call to Dorothy. She always used this painting for her meditations.

Dorothy asked Debora, "Why do I feel so much peace and comfort with this artist's painting?"

Debora replied, "It's a worldwide phenomena. I've got a book about what's happening, by Keith Richardson, a friend of mine from California. The book's called *Andy Lakey's Psychomanteum*. This book explains everything about Andy and his art."

Dorothy thought the book looked interesting, so she purchased a copy and took it home with her. Dorothy placed the book on her coffee table to read later. Due to her illness, Dorothy usually slept on her couch, finding that it made her back feel better while also helping her breathing. That night, Dorothy tried to get to sleep on her couch early. She had a CAT scan scheduled the next morning and she wanted to have plenty of rest.

Something about the book about Andy Lakey wouldn't let her sleep, however. Dorothy felt compelled to pick it up and read it cover to cover. After she had completed the book, Dorothy found herself amazed, realizing why her friend had opened an angel store. She believed that God's angels wanted one here for a reason, and that they wouldn't let her alone until she did what they asked her to do."

The next morning, Dorothy went to the hospital for her CAT scan. When the tests were done, she left the hospital and began to drive home. At this point, Dorothy felt upset. Her head was full of worst-case scenarios of the test results. As she turned the last corner toward her home in Lindsborg, she looked up into the sky. There, she saw a cloud shaped like a glorious angel with its wings outstretched.

"Beautiful," Dorothy said to herself aloud as she pulled her car to the side of the road and watched until the cloud faded away. A thought in her head told her that she had to go to the angel store and sit with the Andy Lakey painting again.

Dorothy started her car and headed into town. As she got to the farmer's CO-OP area of Lindsborg, she noticed a large grain truck. It captured Dorothy's attention because it was so new and shiny. Its chrome was polished to a gleaming brilliance. Its grain trailer was spotless and painted snow white. The truck cab was bright blue.

As Dorothy came to the two sets of railroad tracks in front of the CO-OP, the striking truck pulled out right in front of her, causing her to make a quick stop on the tracks to avoid a collision. Dorothy felt annoyed by the truck driver's apparent rudeness while she sat on the train tracks, wondering what the driver was going to do next.

To Dorothy's horror, she realized that the truck was rapidly moving backward straight toward her car. Dorothy saw she had nowhere to go and he was moving so fast that she did not have time to shift gears anyway. She laid both hands on her car's horn, pushing as hard as she could, she then closed her eyes and prepared for a crash.

Dorothy's horn was blaring when she opened her eyes. The grain truck had come to a stop just one inch from her car. Then he revved up his engine and moved forward again. Dorothy did not want to give the truck another chance to run into her so she pulled her car around the truck and drove up beside it. She then rolled down her window and yelled to the truck driver, "Are you on dope or something?"

The driver looked at Dorothy, gave her a funny look and responded, "Yep"

"I believe it," Dorothy replied upset.

Dorothy then drove past the truck, and when she looked back two blocks later, it was gone. She was a little surprised. The beautiful grain truck had just seemed to vanish into thin air.

Dorothy drove straight to Debora's angel store. She parked, got out of her car and ran into the shop. She moved quickly to the meditation area, took the Andy Lakey star painting off the wall, put it on her lap and sat there for an hour just holding it.

Cynthia, one of the shop workers, came over to Dorothy and asked, "Are you all right? You were white as a sheet when you came in here."

Dorothy began to tell Cynthia what had happened with the truck. While explaining her story, Dorothy stopped talking, put her hands over her mouth, and gasped.

"What's the matter Dorothy?" Cynthia asked puzzled.

"My God, the horn on my car hasn't worked in several months. I was going to have my mechanic look at it the next time I had my car serviced to see if it could be fixed."

Dorothy and Cynthia sat in the shop's meditation room for another half-hour together until Dorothy's friend Debora came back to the shop from her errands. Dorothy and Debora headed to a café up the street for lunch, and as they stepped out of the shop they both looked toward the sky. Above them was a cloud shaped like a beautiful angel in flight.

Dorothy believes that her experiences have been lessons from God. The angels are always with us to bring God's healing, and when it's a person's time to go, their life will end. So people just should not worry about it. God sent Dorothy an angel store, Andy Lakey's art, a book and a grain truck to make sure that she understood His lessons. She believes everyone should live one day at a time, as it is, the best that they can.

Dorothy purchased Andy Lakey's star painting. It continues to bring her peace and comfort. It also shows her that God and His angels are always watching over her.

The Silver Angel Pendant

Bill and Nancy from Woodland, California, near Sacramento, are collectors of Andy Lakey's art. They feel the art is very spiritual and brings love and joy to their lives. They love their Andy Lakey art so much that they decided to share its magic with their granddaughter Kathleen. For Kathleen's twenty-first birthday they purchased a silver pendant in the shape of Andy Lakey's angel figure.

Kathleen fell in love with the pendant immediately, and wore it everywhere she went. One moonless summer evening, Kathleen was returning home from a late night shift as a cashier at an Indian gaming casino when she fell asleep at the wheel at a very treacherous part of the highway.

Kathleen's Volkswagen Rabbit convertible went across three lanes of opposing traffic over a two-hundred-foot embankment and narrowly missed an ancient oak tree. The car came to rest upright. The impact when her car hit the ground was so hard that it knocked out the front and rear windows and completely destroyed the car.

When Kathleen regained consciousness, she climbed out of her car through the back broken window. Except for a few scrapes and bruises, she felt she was okay. She climbed up the two-hundred-foot embankment and flagged down help.

Everyone that saw her car and the extent of her accident felt it was a miracle that she survived moderately unhurt. Kathleen believes God's angels saved her, and that having Andy Lakey's silver pendant around her neck allowed her to open her heart to receiving this help.

Healing Angel Necklaces

Donna's sister bought her an Andy Lakey necklace pendant soon after Donna purchased her first painting by the artist. She immediately fell in love with her beautiful spiritual piece of jewelry. The pendant gave Donna a sense of security whenever she wore it.

For her friend Sue's birthday, Donna and one of her co-workers bought her an Andy Lakey angel necklace. They did not want to wait for Sue's actual birth date to give her the gift, so they decided to give it to her a few days earlier during their lunch break.

Just before noon, Sue received an urgent call from her husband. It was terrible news. One of Sue's daughters had just been in a head-on automobile collision. She was being flown to the

trauma center of a local hospital. Donna and her co-workers came to her aid. They all prayed together for Sue's daughter's recovery.

As Sue was about to leave for the hospital, Donna remembered the angel necklace. She put it in Sue's purse and said, "Open this gift as soon as you get to the hospital."

Later that evening, Donna and her co-workers went to the hospital's intensive care unit and held a prayer vigil for Sue's daughter. Donna noticed that Sue had her angel necklace on. She said she felt secure her daughter would pull through. Miraculously, despite extensive injuries, Sue's daughter did survive and within just a few weeks she was released from the hospital.

Sue told Donna that Andy's angel was like a message sent from God that her daughter was protected. Sue was amazed that her friends would give her this gift on the exact day that she needed it.

Since Sue had gotten so much peace and tranquility from her angel necklace, she felt it was her duty to share it with her co-workers who were going through rough times. One co-worker's mother died and she was going through a difficult grief process. Sue loaned her the necklace. The woman felt so comforted by the necklace that she did not want to return it. Sue gave the necklace to the woman and purchased another one.

Another co-worker was having trouble with her teenage son. Sue lent the woman her necklace. The woman lent the

necklace to her son. The youth turned his life around, never taking the necklace off.

Sue then purchased two other Andy Lakey angel necklaces, one for herself and one for her mother. Sue wore her necklace for several months, and then lent it out to a co- worker who was having marital problems. Sue finds happiness in knowing that she can give a gift of comfort to others just as Donna and her co-workers did for her.

CHAPTER TEN

Synchronicity

In James Redfield's book, *The Celestine Prophecy*, he explains that meaningful coincidences are brought to people to make a point about where they are in their lives. I continue to have these types of synchronistic events occurring daily in my life. I have learned that this synchronicity happens to me and the people around me.

Sometimes I am brought together with people just because I need their help in my life. Sometimes I find that the people I meet need my assistance in a difficult life decision. Other times, I feel these encounters are just brought to me to make a spiritual point. The major message I continue to receive is that we really do not have as much control over our world, or the universe, as we perceive. There are always divine forces at work all around us. There is a great deal more to life than meets the eye, so we try not to worry and instead just sit back, have fun and enjoy the ride.

Lost and Found Again in Santa Barbara

It was May 11, 1996, and Andy Lakey had just completed an exhausting weekend of personal appearances at our store. I had agreed to drive Lakey back to his hotel in Santa Barbara, about a forty-five minute drive away. My wife Francesca and my son Kevin, who had both worked the long and busy days in our store, accompanied me in our family van to take Lakey to his hotel.

I had called for directions to the hotel that morning, I wrote them down on a piece of paper, and I remembered later putting what I believed to be those directions in my pocket. As we reached the city line for Santa Barbara on the freeway, I reached into my pocket to find out that I had the wrong piece of paper. I looked embarrassedly at Andy and told him of my mistake. He said he did not know how to get to his hotel either. So, I tried to follow the directions I had received on the telephone by memory.

They said the hotel was on Bath Street, but not to get off on Bath because it was a one-way street going the wrong direction. I was to get off on another street, but I could not remember the name, and cut into Bath Street from there.

We passed Bath Street and I decided that the logical choice would be to get off at the next exit, Carrillo Street. I went down Carrillo Street for quite a long way and became concerned that maybe Bath Street ran parallel to Carrillo Street. I turned right at

the next opportunity and went down several miles. Bath Street did not appear.

By this time I was hopelessly lost. In a time before cell phones or GPS systems, we were in a street gang area of Santa Barbara, and I was becoming a little scared. Everything was shut down, and it was getting late. Andy suggested we find a telephone booth and he would call directory assistance, get the number of his hotel and call for directions. Among all four of us in the van, we had just one quarter. I gave it to Andy. He called directory assistance and they gave him the wrong number. I felt scared, embarrassed, confused, and incredibly lost. I felt terrible for Andy. I knew he must have been exhausted, hungry and missing his wife and children who were staying at the hotel with him. To my astonishment, Lakey was not at all concerned. He seemed amazed and excited by the situation.

Andy explained to us, "Guys, something amazing is happening. Don't be concerned. Don't be afraid. We're right where we're supposed to be. For some reason the universe has diverted us to this spot. There are no coincidences! Maybe we would have been in an accident, or maybe there's a message we are supposed to receive. Anyway, when the time comes for us to get where we're supposed to be, we'll get there."

Andy's take on the situation was a relief. I did not believe it, but I was glad Andy did anyway. I headed west and eventually

found State Street, a road that I was familiar with. I turned right on State Street and got back to Carrillo Street. There, I found a gas station and stopped and asked for directions. They told me Bath Street was just two blocks down. The street isn't marked coming into town, only going out of town.

I drove to Bath Street and made a right turn. Something did not seem right. This seemed to be a residential area. There were houses and apartments. There was no sign of a hotel. As we went down the street something caught my eye. One of the little houses had been converted into a Japanese restaurant.

I asked, "That looks like an interesting place to eat, would you like to stop there?"

We were all starving by this point and did not know when we would find the hotel. There was an instant consensus. There was a place to park directly across the street from the restaurant. I parked and we all got out. We went into the restaurant and were seated. Our server came to our table and we discovered she only spoke a limited amount of English. Andy had spent part of his childhood in Japan and can speak almost fluent Japanese. Andy then began to order in Japanese. As he did this, my wife Francesca, who was born in Nicaragua, Central America, looked the server in the eye and questioned, "Don't I know you?"

This scene seemed a little strange to me. I sarcastically thought that she probably knew her from a past-life or something,

figuring that my wife had just confused the server with someone else. But, then things got even stranger, the woman looked at my wife and said, "I know you too. I went to your wedding."

My wife and the Japanese woman, who with her husband owned the little Japanese restaurant, had graduated from a special English program at Roosevelt High School in Los Angeles together in 1974. The last time we had seen her was at our wedding on May 10, 1975. That was twenty-one years earlier, nearly to the day.

Andy Lakey sat in amazement as he watched this unbelievable coincidence occur, then he told us, "What are the odds of this? One in a million? One in ten million? I told you we were being diverted. I told you something was going to happen. I told you there were no coincidences."

After dinner we said goodbye to our long lost friend. I drove about four blocks down Bath Street and found Andy's hotel. We dropped Andy off and headed back. I found that within a block from Andy's hotel there was a freeway on ramp. If we had gone one more street down on the freeway, we would have been right at Andy's hotel, and none of the coincidences would have occurred.

But, the story doesn't end there. In March of 1998, Andy Lakey moved his home and studio from Murrieta, California to Santa Barbara, California. As I followed Andy's directions to his new studio, I realized something very amazing. The directions

were almost identical to those I describe in my story of being lost in 1996.

The directions included exiting the freeway at Carrillo Street, passing Bath Street which runs one-way in the wrong direction, then going to the gas station where we asked for directions and there turning right and driving two blocks to Andy's studio. The path that we took in 1996 made a circle around the location of Andy's Santa Barbara studio. He was not aware of this coincidence until I brought it to his attention.

In June of 1998, Francesca and I had an evening meeting with Andy Lakey at his studio. After our meeting, Francesca and I asked Andy to come with us for dinner. Andy declined our invitation because he was getting ready for a major exhibit and had to work late on several pieces of art.

Francesca and I decided to visit our friends at the Japanese restaurant. We had not been to this restaurant since the night we were lost in Santa Barbara with Andy Lakey. When we arrived, we found an empty table and sat down. A young Japanese woman came to our table and asked for our order. Francesca looked at the woman and smiled then asked, "Where's Misako?"

The woman looked down and shook her head, then explained, "Misako and her husband don't own this restaurant anymore. They sold it to us in March. They moved to San Francisco last month."

At first Francesca and I were upset. We had waited over two years to return to this restaurant. We felt guilty about not coming to see Misako and her husband sooner, and then, when we finally did go to see them, we found out that we had missed them by just one month. Francesca and I sat at our table looking at each other, trying to figure out what was happening.

"This is really strange, isn't it?" I questioned. "It's as if we were taken on some sort of vision quest back in 1996. We were blown away. We learned a lesson about the spiritual world's control over our destiny. And now that Andy has moved to Santa Barbara, and this lesson isn't needed anymore, we've been given a new lesson."

Francesca looked back at me, she smiled, and said, "Keith, don't you see what's happening? We were guided here in 1996 and we've been guided back here again today. Two years ago we were shown an important spot in our future lives. Misako and her restaurant are no longer part of our lesson. She and her husband have been allowed to move on to pursue their own destinies. Andy had to be with us in 1996, so he could find the location of his future studio. Andy didn't have to be with us tonight. This lesson was just for you and me. We have to know that things happen for a reason and that things change for a reason. We've been brought here tonight to learn this lesson."

What are We Doing at the Mall?

One day in mid-June, I got a major order out of the blue. A lady from Northern California wanted the most expensive piece of Andy Lakey jewelry that we carried. The piece was an 18-karat gold angel pendant with a diamond in the center. The price of the piece was $820. We had the piece for over two years in our jewelry case, and this was the first one we had ever sold.

As we discussed her purchase, the lady asked, "Does this piece come with a chain?"

Being anxious to close the sale of such a significant piece of jewelry, I replied, "Sure it does."

Upon getting the woman's credit card and hanging up I realized I had made a promise for a gold chain and I did not know if could fulfill my promise. I told Francesca about the significant jewelry sale and asked, "Do we have a gold chain? I promised the woman I would give her a chain with this piece."

"No," Francesca replied, "we don't have a gold chain in the store."

"Where do you think we can get one? I did make a promise to her."

"Why don't you try the jewelry store down the block?" suggested Francesca.

I walked to the jewelry store and they suggested a 14-karat gold chain. I purchased one and showed it to Francesca and she

said, "No! This chain won't do. It's too thin for this piece. It's not right for the piece. We're going to have to go to the Oxnard mall to find what we need."

That evening after work, Francesca and I went to the mall in Oxnard. We first went to one of the mall's department stores. We found, to our concern, that the least expensive gold chain they carried cost $250. We continued on through the mall and found the prices for gold chains were the same everywhere.

"We won't make a profit on our sale if we give the lady a $250 chain," I told Francesca, worried.

"You're right, Keith. Why did you promise that lady a gold chain anyway?"

"I thought maybe we had a gold filled or gold plate chain we could give her."

"Why didn't you tell me this in the first place?" responded Francesca. "I thought you meant we needed a 'gold' chain. We have sterling silver chains in the store that are triple plated with 14-karat gold. We could have given her one of those."

"Why didn't you tell me about these chains?" I replied.

"I thought you meant you wanted to give the lady a 'gold' chain," Francesca responded with annoyed frustration.

"To me a sterling silver chain, triple plated with 14-karat gold, is a 'gold' chain," I explained, realizing the humor of the

situation. We both stood in the center of the mall and smiled at each other. "What are we doing here?"

"I don't know. This is really dumb isn't it?" replied Francesca.

"This is really weird, we've seen before there are no coincidences. We've been directed to this mall for a reason by the universe. Something 'mind blowing' is about to happen."

Francesca shook her head smiling and told me, "I think you've been reading your own books too much. Let's go home. It's late, and I'm tired and starving."

Francesca and I walked to the other end of the mall where we parked our car. We got in and started to back out, and then something unusual occurred. We saw a car enter the space directly in front of us. Its occupants seemed very excited. They were waving their hands and honking the horn.

"They're probably our customers from the store," said Francesca.

"I don't recognize them," I said.

I stopped the car, and then Francesca went to find out what they wanted. To our shock, it was some friends of ours that we had not seen for over seventeen years. It turned out they had lived in the Oxnard area for eleven years and had asked mutual friends about us over the years, only to be told we had moved far away.

"What are the odds of this happening?" I said, quoting Lakey during our similar experience earlier, "One in a million? One in ten million?"

Whenever you're diverted to the wrong place, or it seems that things have gotten a little beyond your control, watch out, because you may have been diverted by the universe to find a very important meaningful experience in your life.

Angels in New Orleans

Debbie, from Ohio, is committed to Andy and his art. She has attended several of his art shows across the United States. In April of 1998, Debbie attended Andy's New Orleans, Louisiana art opening.

For this event, Debbie decided to wear a beautiful pin Andy had given to her the year before. The pin had one of Andy's angels painted on it. Above the angel was a rainbow. Andy had given the pin to Debbie in commemoration of the ten year anniversary of the death of her daughter, Dana. Dana had died in an automobile accident on September 19, 1988. Debbie feels that her daughter sends rainbows to heal her grief.

Whenever she wears her pin, Debbie meets people who tell her stories about losing loved ones. While standing at the back of the New Orleans art gallery where Andy's art show was presented, Debbie noticed a tall blonde-haired woman walking toward her.

The woman seemed to be staring at Debbie, but she was not looking at her face. She was looking at Debbie's rainbow angel pin.

The woman looked up at Debbie and said, "I love your angel pin."

"It's pretty isn't it? Would you like to touch it?" Debbie replied.

The woman nodded her head yes.

Debbie took the pin off and handed it to the woman. She held the pin gently in her hands and caressed it like a baby. Debbie and the woman chatted for a few moments about their lives. Debbie told the woman she had come all the way from Ohio. The woman told Debbie she had come all the way from Wyoming specifically to attend this art event.

As they spoke, Debbie could sense a deep feeling of sadness from the woman. It was as though she seemed to want to tell her something from deep within her heart, but it was too painful to say.

Finally, the woman took a deep breath, sighed and then said, "I lost my sixteen-year-old daughter two years ago in a car accident."

Debbie was shocked by the revelation, but instinctively responded, "I lost my daughter nine years ago, in a car accident too."

A tear fell from the woman's eye as she realized the connection she had with Debbie. "How do you get to nine years? What is the miracle cure? What book do you read to help you?"

"You are so new to grief and I'm not sure you'll understand what I'm about to say, but someday you will," Debbie replied. "It doesn't matter how much money you have or how many people love you or how many books you read. You will only get better when you decide to get better. It's all up to us to make our lives worthwhile."

The woman said she understood Debbie's philosophy, and this made a big difference in how she felt about life and grief. Debbie decided to give the woman a gift that would help her with her grief. It was a book of poems that Debbie had written on dealing with the grief of losing her daughter Dana.

On receiving the offer of the book from Debbie, the woman smiled and thanked her. She told Debbie, "You know, I have a favorite book that helps me with my grief already, but I'd love to read yours too."

Debbie handed the woman the book. She took it in her hands and looked at the cover. Her mouth hung open wide as she gasped and exclaimed, "This is my favorite book. I can't believe it. I'm really meeting you in person. I carry your book with me everywhere. I know some of your poems by heart."

The woman reached down and produced a copy of Debbie's book, *September's Child*, from her purse.

Both women were moved by the synchronicity of their experience. Debbie believes that her daughter and this woman's daughter met in heaven and decided to make their mother's meet on earth. Debbie feels that Andy Lakey's angel paintings were the common link between them that brought them together.

Anna Lee's Lesson

Anna Lee's story is both moving and inspiring. It has been printed in *Life Magazine* and featured on many television shows including *Extra*. Anna's story was first brought to my attention in April of 1997 when Andy Lakey called and told me to get a copy of *Life Magazine* for my store. In the magazine was a full-page article about Anna Lee. It showed a photograph of her wearing a black dress with one of Andy's diamond shaped art pins worn over her heart.

In Gulfport, Mississippi in 1996 Anna Lee and her four-year-old daughter Whitney were on their way home from the grocery store when they came to a railroad crossing. There, they waited for a long freight train to pass. As they waited, a seventeen year-old youth named Dan headed into the same railroad crossing. Dan was distracted. He had drunk several beers and had an open can of beer between his legs. He did not notice the traffic had

stopped. Without slowing, Dan plowed into Ana Lee's car, killing her daughter Whitney instantly.

The Mississippi court system had no mercy on Dan. Although this was his first criminal offence, Dan was given twenty years in prison for vehicular manslaughter. He was also made to pay $500 restitution to Anna Lee. Dan was to pay this in checks of $1.00 each. On each check he was directed to write: "For causing the death of your daughter Whitney."

At first, Anna Lee hated Dan for his recklessness and stupidity. She was glad he got the severe penalty he received, feeling that he really deserved it.

After a while, however, Anna Lee began to feel she had to meet Dan. She believed the only way she could truly heal from the loss of her daughter was to find forgiveness in her heart for Dan. Anna Lee arranged to visit Dan in prison. As she got to know him, she not only found forgiveness, but she also found love in her heart for him.

Today, she and Dan give presentations to high school students throughout the state of Mississippi on the dangers of drunk driving. The prison officials offered to allow Dan to wear civilian clothes for the lectures, but he opted to wear his bright orange prison uniform instead. Dan feels this gives a more dramatic, yet still honest, look at the burdens of prison life.

When Andy Lakey saw this story in *Life Magazine,* he contacted one of his friends that worked at the magazine and got Anna Lee's phone number. He called her and spoke to her for about half an hour. Andy was so impressed by Anna Lee's commitment to her cause, that he sent her a dozen more of his art pins for the other members of her anti-drunken driving group.

In April of 1998, Francesca and I traveled to New Orleans, Louisiana to attend one of Andy Lakey's art openings. One of Andy's major collectors, who had read my book, *Andy Lakey's Psychomanteum,* had some friends with him and asked if I would sell copies of my book to them. I went out into the rainy night and pulled out a box of my books from the trunk of the car we were using, and lugged them back to the event.

There, over a dozen people, all of whom wanted me to inscribe and sign a book for them, mobbed me. As I frantically signed books, I felt someone tug the sleeve of the sports coat I was wearing.

A female voice said, "I need to have a copy of your book."

I glanced back, and to my astonishment, I recognized the person that was speaking to me. It was her, Anna Lee from the magazine article in my gallery. She had short, dark brown hair and bright brown eyes. She even wore a black dress and the Lakey art pin she had on in the *Life Magazine* article.

"I know you," I said.

"How can you know me?" she replied.

"I saw your picture in *Life Magazine* and on the television program *Extra*. I even have the article with your picture in it in my art gallery in Ventura, California," I explained.

Anna Lee looked at me a little embarrassed and said, "Yes, you're right, that's me."

I called to Francesca, who was talking to people at the other end of the gallery, and when she came over, I said, "Do you recognize this woman?"

Francesca nodded her head yes, and responded, "It's the lady from the article in *Life Magazine,* right?"

The three of us talked for about twenty minutes, then the event ended and we had to go our own ways. Anna Lee told us she had six appointments with schools in the following week to give presentations with Dan on the dangers of drunk driving.

Angels along the Road

During a trip to Kansas in June of 1998, my wife Francesca and I returned to the Wichita airport on the highway that runs from Kansas City to Wichita. We had lived in Kansas for just over three years between 1989 and 1992, but we had never traveled on this road before.

About halfway to Wichita, Francesca noticed an interesting cloud in the sky ahead of us. The cloud had a strong resemblance

to the angels painted by Andy Lakey. The angel had a long narrow torso with stub-like arms extending from it. Its head was oval and stood unattached to the torso. The only thing that differentiated this figure from Andy's angels was its feathery windblown look. The cloud appeared to follow us all the way. Francesca was so impressed by the cloud that she wanted to photograph it. She reached for our camera, but noticed, to her dismay, that we had used the last of our film.

We talked about this cloud all the way back to our home in Oxnard, California. Francesca just could not get the angel's image out of her mind.

About two weeks later we had a meeting with Andy Lakey in Santa Barbara, California. Francesca took out her note pad to take notes about the meeting. At a slow point in our discussion, Francesca sketched the angel we had seen over us in the skies of Kansas. At the bottom of the page she wrote, "From Kansas City to Wichita."

Francesca handed the drawing to Andy and said, "Can you believe we saw an angel just like yours in the skies of Kansas?"

Andy turned pale as he looked at the sketch and read its title out loud, "From Kansas City to Wichita." Andy sat silently for a moment then said, "Oh my God! The road from Kansas City to Wichita, that's where an emotional point in my life occurred, that was the last place I was with my grandparents."

Francesca and I were both surprised to learn that Andy Lakey had ever even been to Kansas, and we were curious to hear more about his emotional experience.

"When I was eight years old," Andy continued, "my family moved from Japan, where my stepfather was stationed in the military, to Wichita. While they were getting settled, they sent me to stay with my grandparents in Kansas City, Missouri. This was one of the happiest times of my life. My grandparents were wonderful people. They treated me with kindness and love. My household with my parents was never that way. I was sad when the day came for them to return me to my family. They took the highway from Kansas City to Wichita. Within ten minutes after dropping me off, my grandparents were involved in a terrible automobile accident. My grandfather was killed. My grandmother was paralyzed and later died of her injuries. My life was never the same after that."

Andy then took the angel sketch and analyzed it more closely. "That cloud was a message from my grandparents," he told us. "They gave you this message in Kansas so you'd bring it to me. They just wanted to let me know they're okay and they're always watching over of me."

EPILOGUE:

What Does it all Mean?

By now you may be asking yourself, "What does it all mean? What is really happening to people who come in contact with Andy Lakey's art? Is it just wishful thinking, or are they really having a true spiritual encounter with the other side?"

This question is asked of me over and over by people from throughout the United States and around the world. This debate reminds me of a story told by one of my high school professors. In the story, he described the endeavors of a young woman assigned to do a report on the symbolism of John Steinbeck's book, *The Pearl.*

The Pearl is a story of a young couple that put their quest for personal wealth ahead of their family and their spiritual life. In the end, their efforts to acquire a large black pearl lead to the death of their child and their understanding of an important spiritual lesson.

The most puzzling piece of symbolism for the young woman assigned to do the report was the reference to the "Eyes of

the Night." This unseen, but often-menacing, element of Steinbeck's story appears to evoke fear in the characters.

According to my professor, the young woman was quite industrious and somehow acquired the home phone number of John Steinbeck. She called him up, introduced herself and said, "Mr. Steinbeck, my teacher gave me an assignment to do a report on the symbolism of your book, *The Pearl*. What do the 'Eyes of the Night' in your story mean?"

There was silence on the other side of the line for a moment, then Mr. Steinbeck replied, "They can mean anything you want them to mean my dear. It's up to you to find their significance in your own heart. You don't have to get this from me or anybody else. It all rests with you alone."

Just as John Steinbeck explained to the young woman about the "Eyes of the Night," it is up to each of us to find our own meaning from the art of Andy Lakey. It is also up to us to find love in our hearts and follow of our own paths to God. Through this process, we may embrace the spirituality and love we discover on our journey, our long journey, back home. Home to the place we call heaven.

ABOUT THE AUTHOR

Keith P. Richardson is a trained scientist who holds a masters degree in anthropology and has conducted field research in Asia and Central America. He has spoken at national anthropology conferences and published articles in scholarly journals in the field.

Since April of 1995, Richardson has owned a successful retail store in Ventura, California named "Things From Heaven." This store and the stories from Richardson's books have been featured in numerous newspaper and magazine articles, as well as local national and international radio programs and television specials. His major television credits include ABC's *Good Morning America* and *The Caryl and Maryln Show*; CNN's *The Life and Times of Angel encounters,* Fox Television's *Miracles in the Making,* CBS Television's *The Prayer Store* and *Earth Angel* and internationally syndicated cable television talk shows *Bridging Heaven* and *Earth and Angels are for Real.*

Richardson is the author of four books on spirituality which have been published in English, Japanese and Portuguese. He continues to give lectures on numerous spiritual topics at

universities, hospitals and spiritual and religious organizations throughout the United States and Japan.

Richardson is an ordained minister in the Church of Religious Science. In this capacity, he conducts weekly services and monthly prayer meetings, as well as, weddings, baptisms and funerals.

Richardson and his wife Francesca reside in Oxnard, California. Their two sons Keith William and Kevin reside in Ventura County, California.

Breinigsville, PA USA
07 September 2010
244886BV00001B/1/P